By Bong Yogore, my cousin, circa 2017

WELCOME! We hope you will enjoy this Fave Art-14 album of random collection of art. Most art works are copied from the internet, posters, pictures and books & friends. You may display this book as coffee table book in your living room, as conversation piece. You may give this as gift. You may cut out and frame each page. Each art work is 8.5x11 inches and suitable for framing, and for wall decors. The ISBN Code Numbers of this book are:
ISBN-13: 978- 1548425883 & ISBN-10: 1548425885
Printed in USA, 2017. Free to copy by anybody. Why copy? Just buy the book.
Contact: job_elizes@yahoo.com (Tatay Jobo Elizes, Self-Publisher)
http://tinyurl.com/mj76ccq & http://www.jobelizes6.wix.com/mysite.

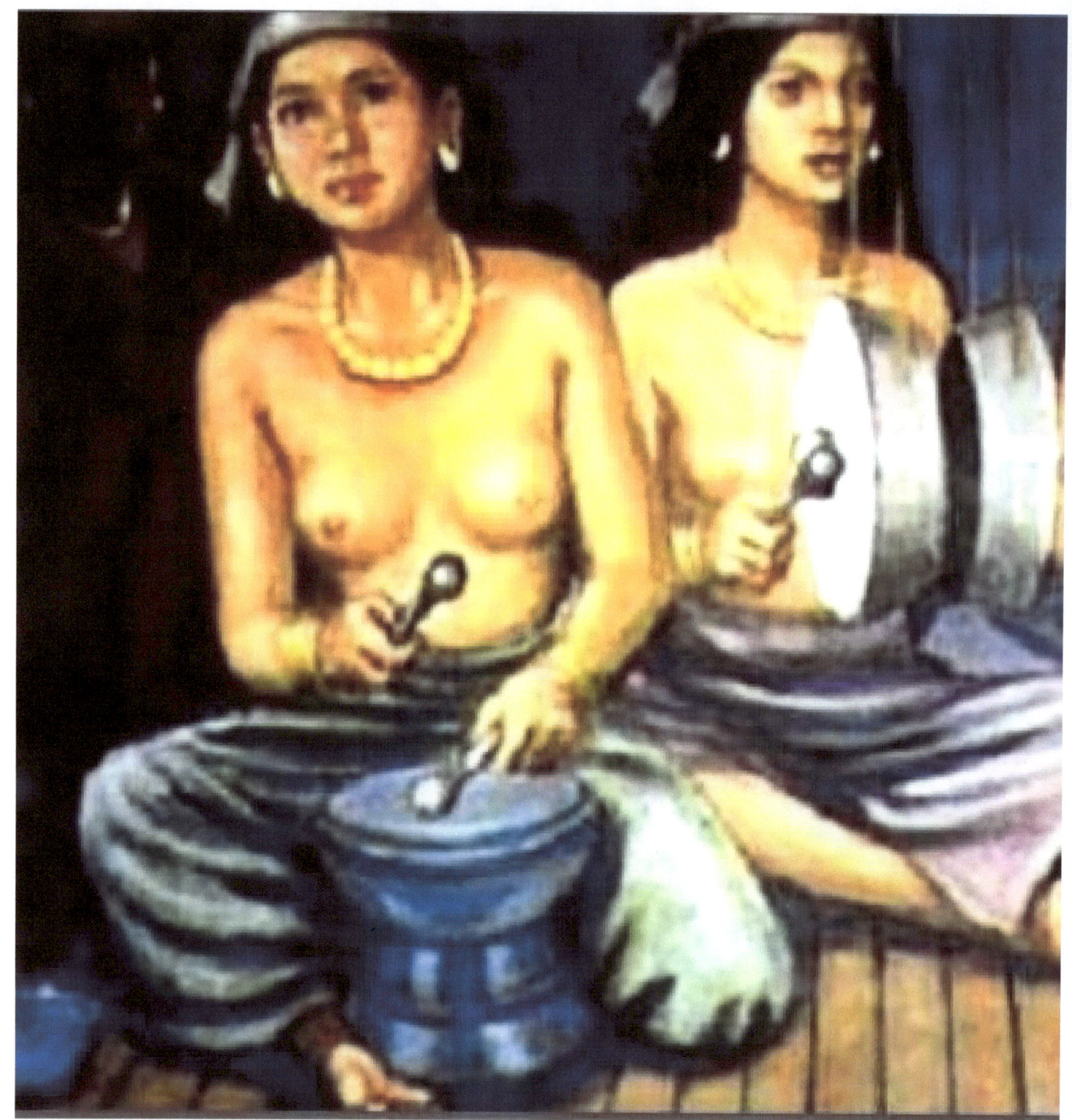
A Philippine Art

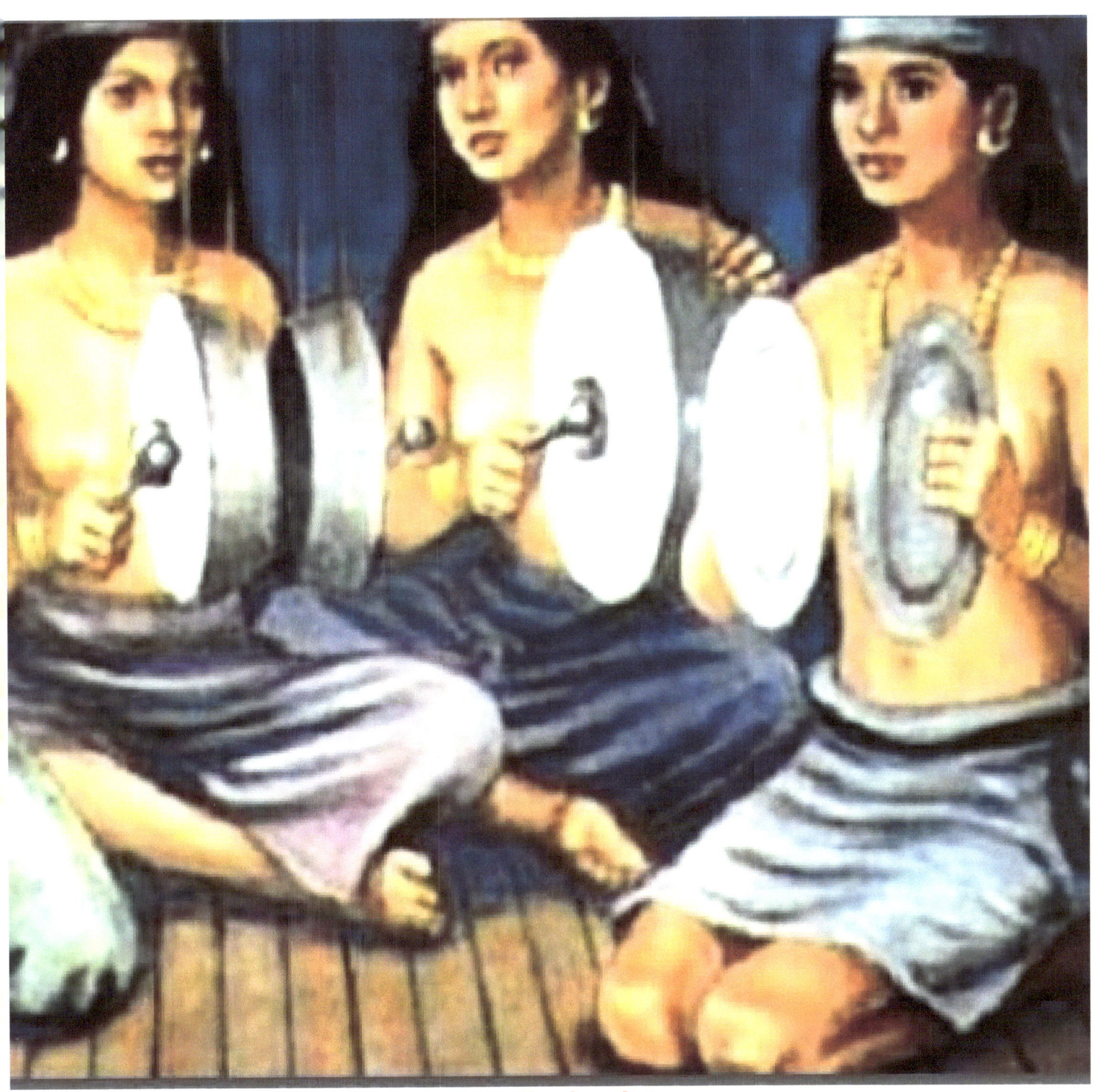

A Philippine Art

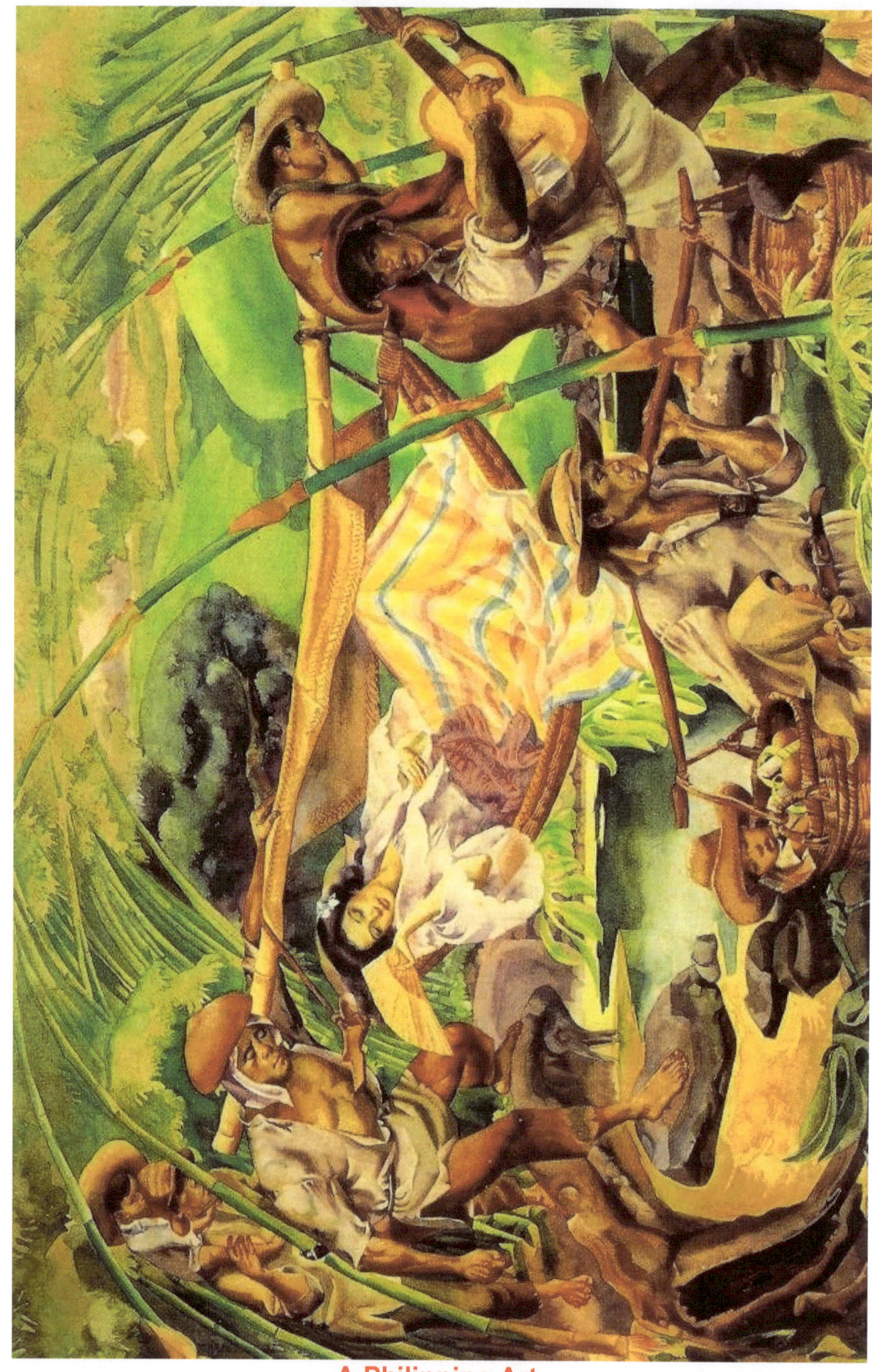

A Philippine Art

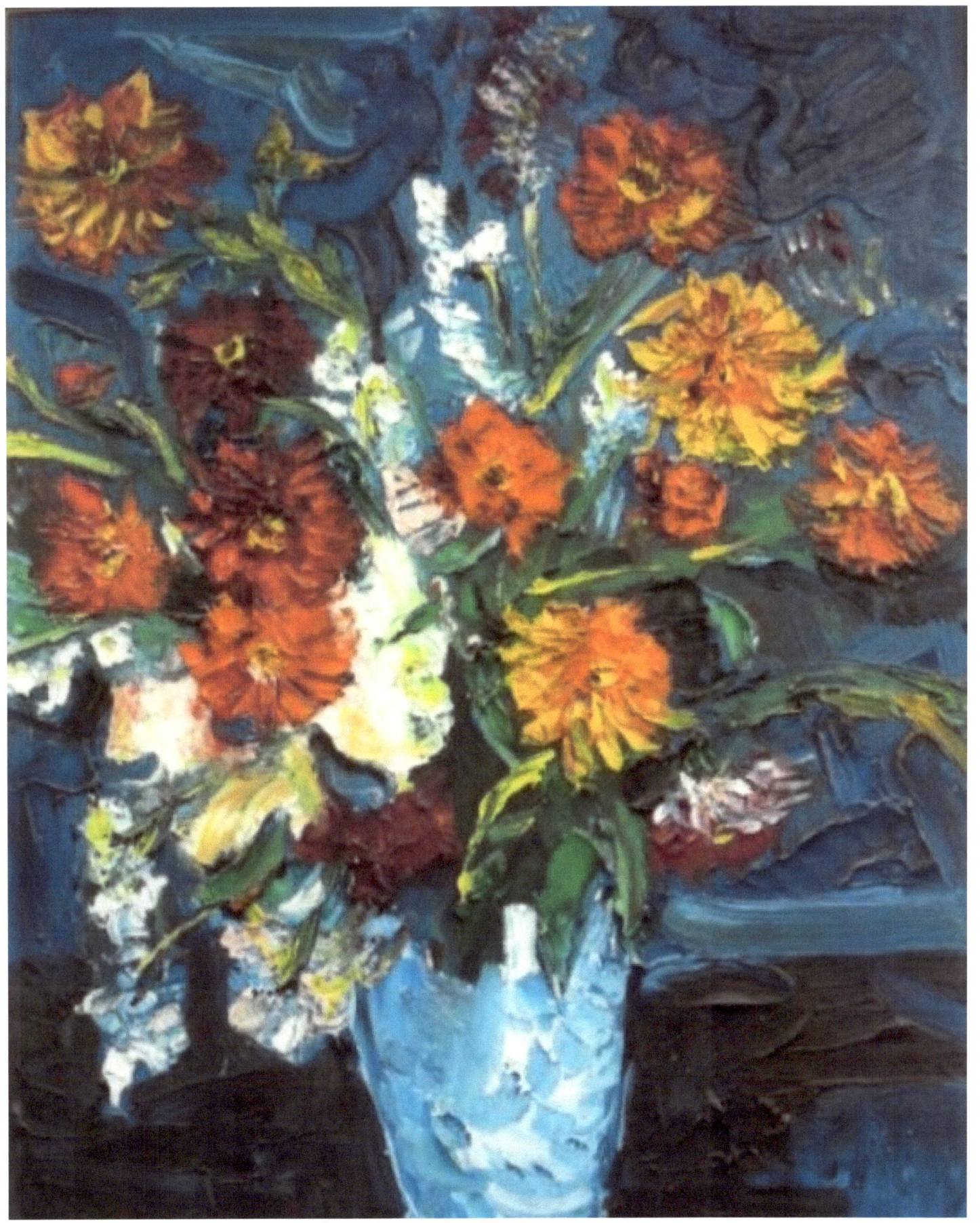
American Art, Unknown artist

A Vicente Manansala classic – Saying Grace

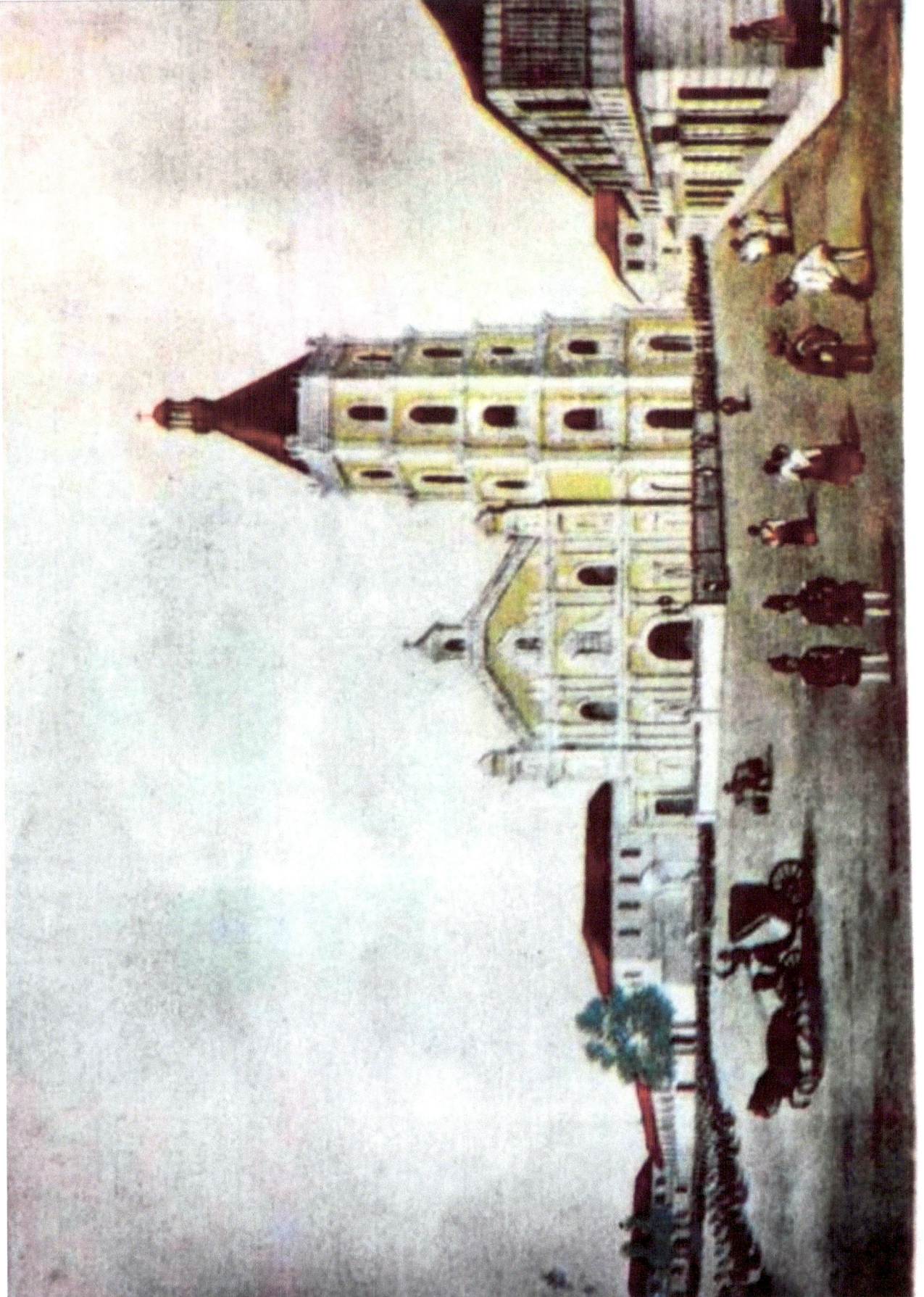

Binondo Church, Manila in old painting

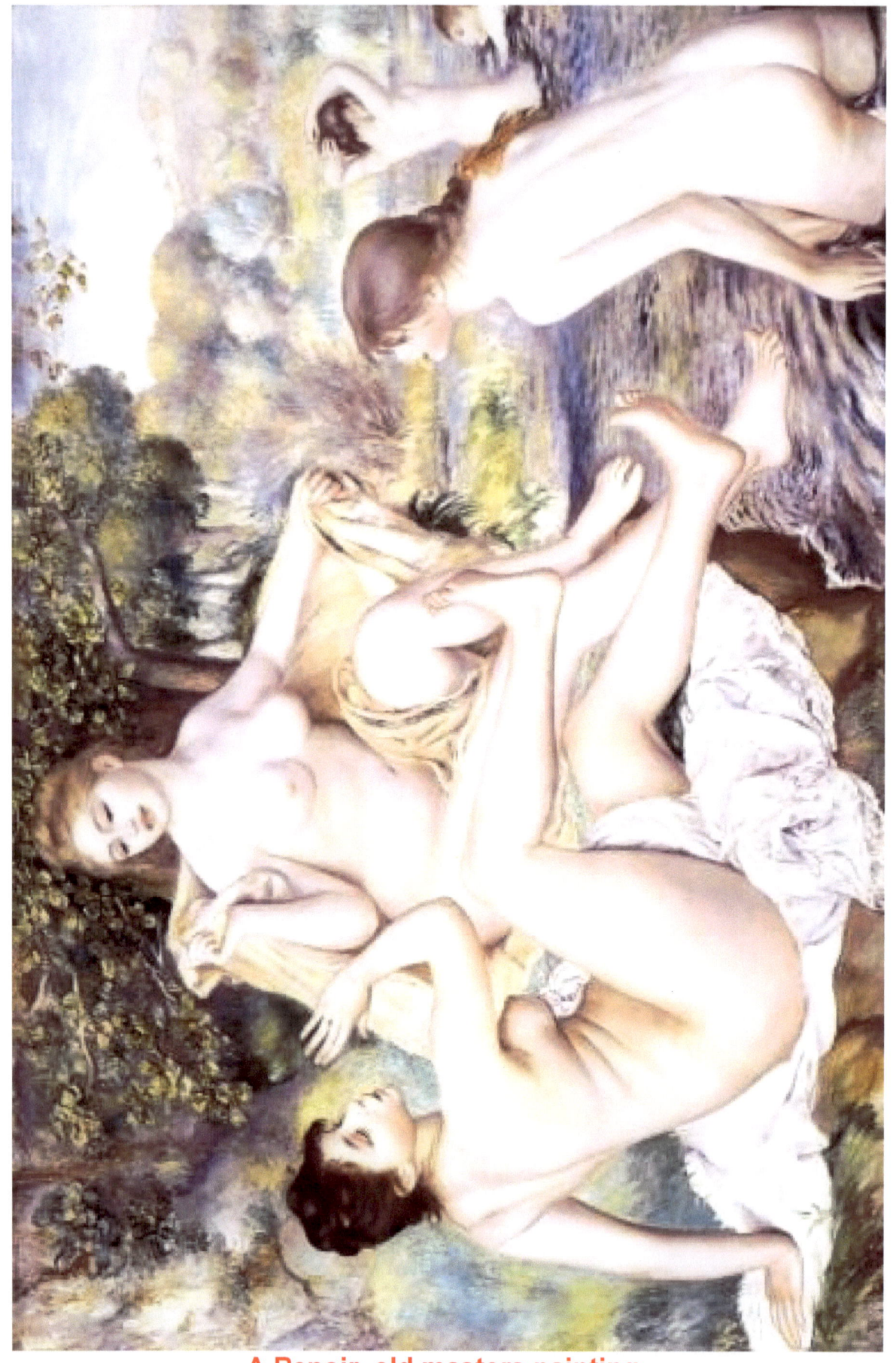
A Renoir, old masters painting

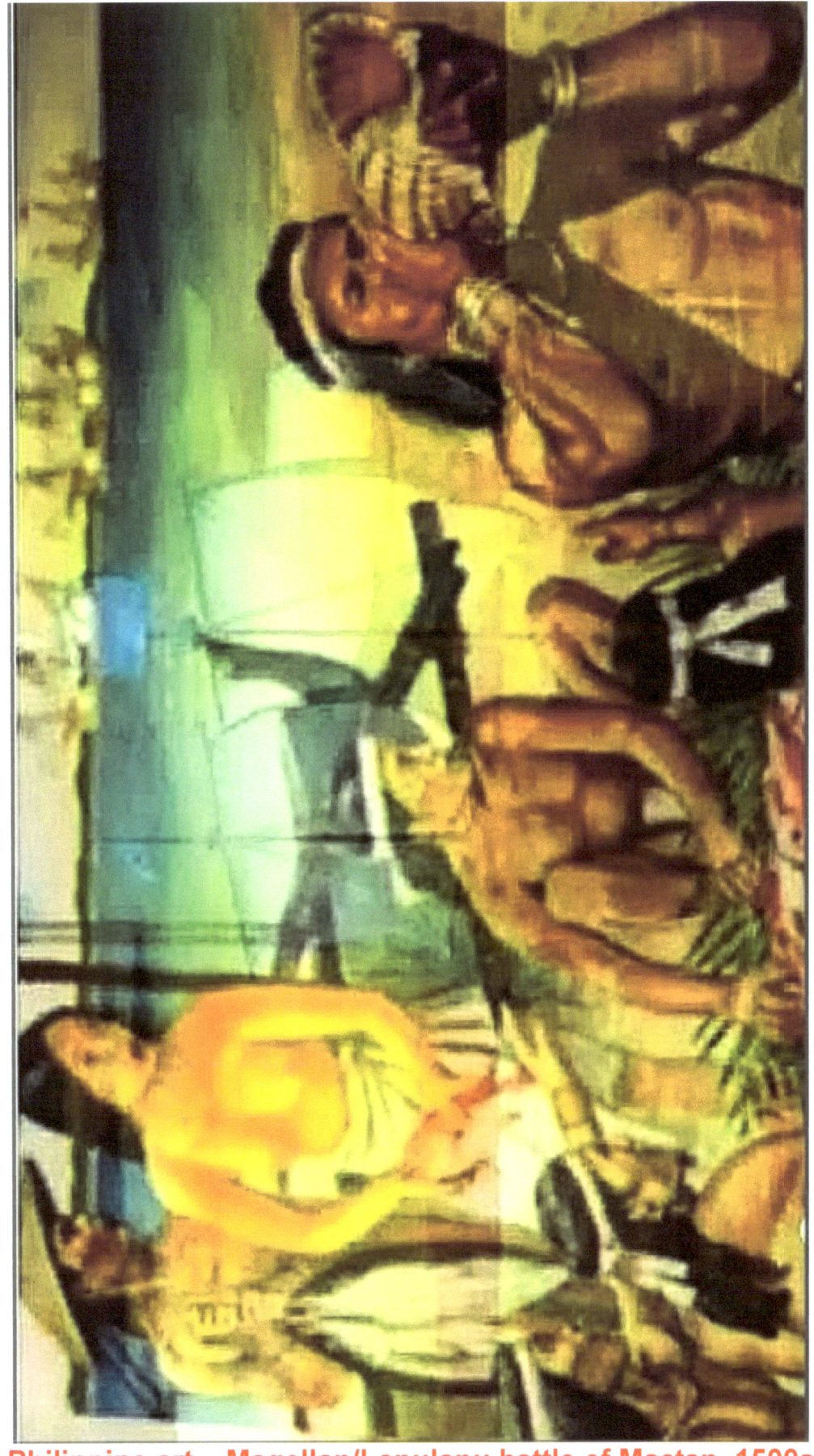
Philippine art – Magellan/Lapulapu battle of Mactan, 1500s

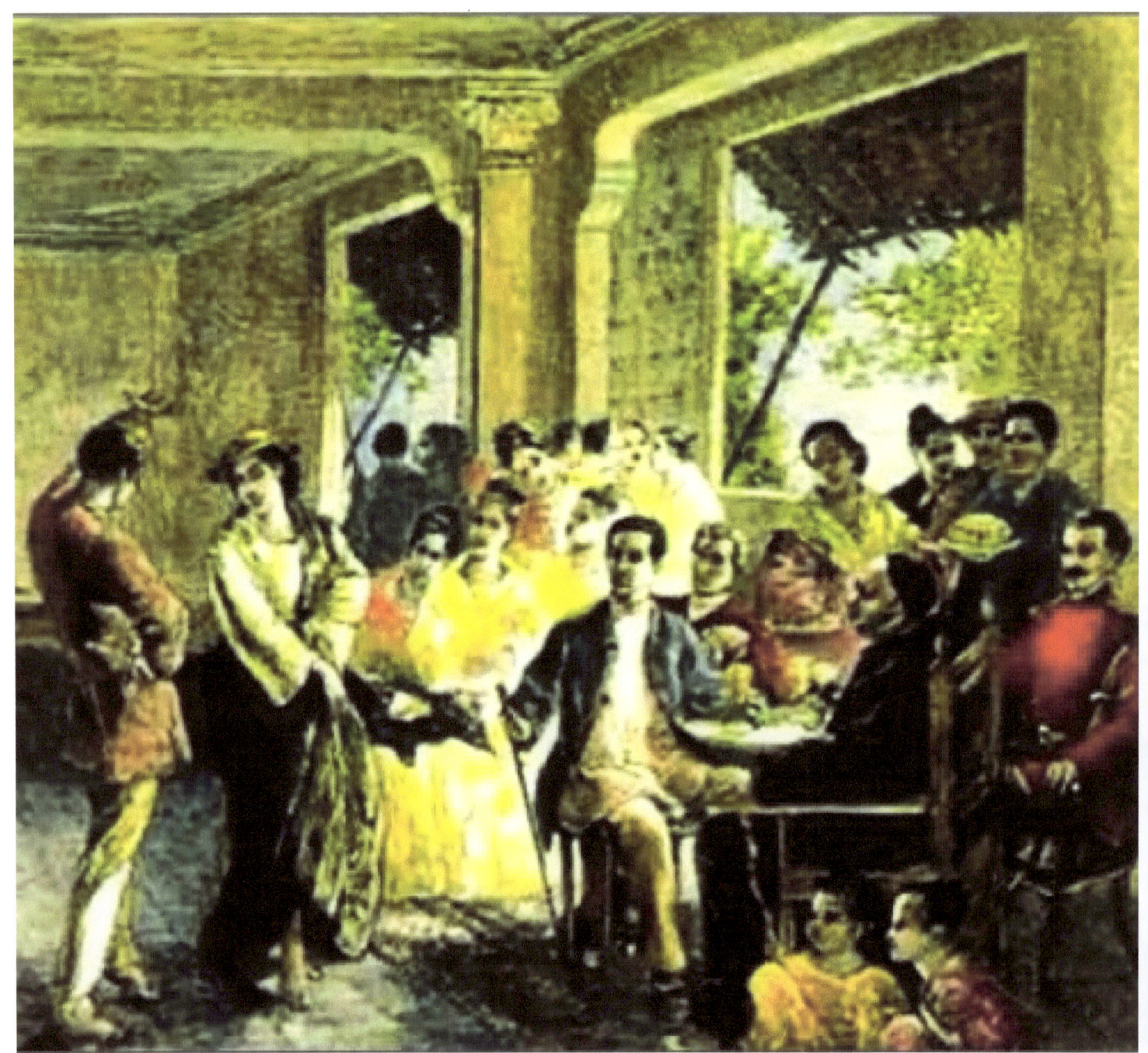

Old Philippine Scene - Artist unokown

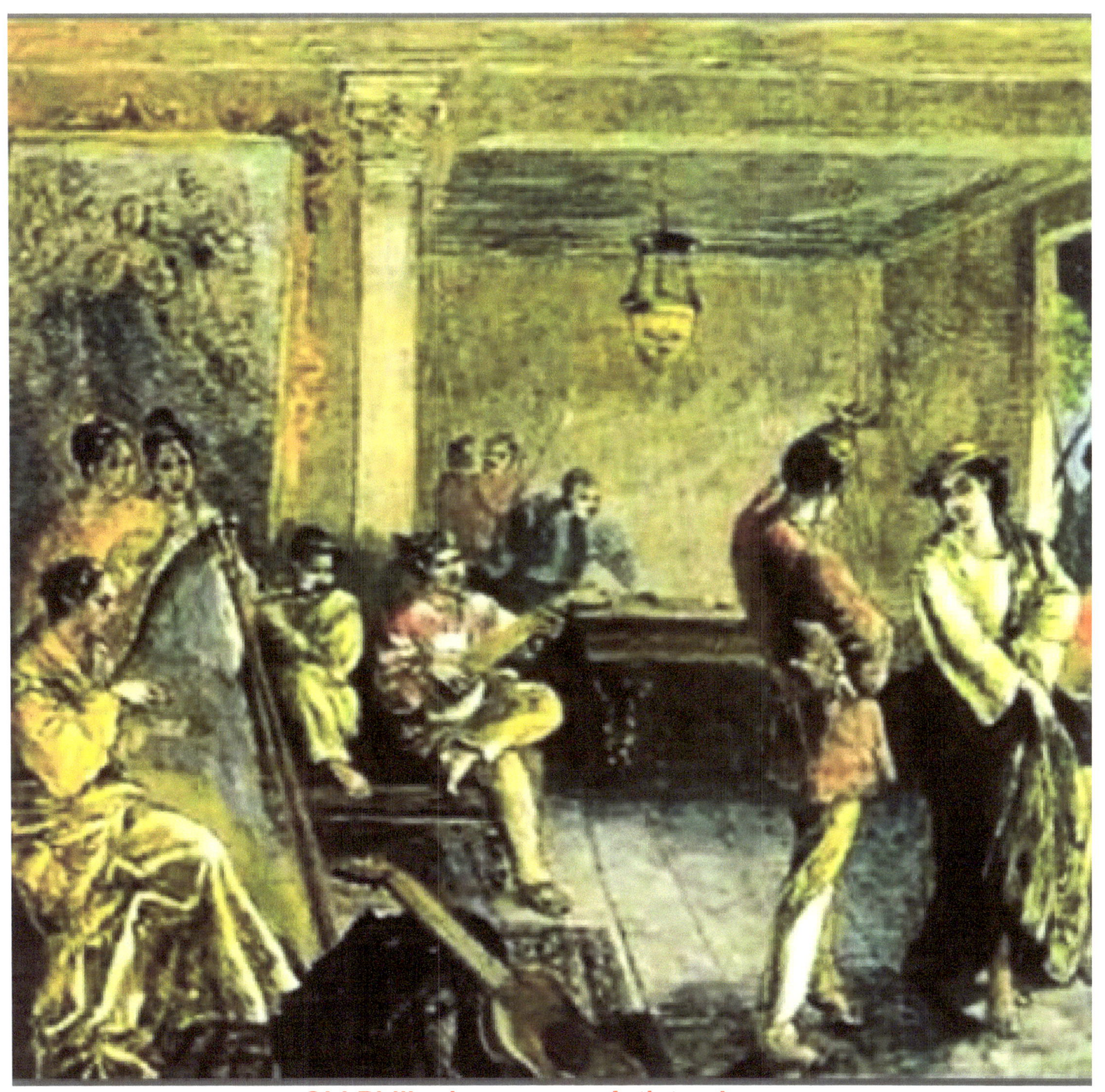

Old Philippine scene – Artist unknown

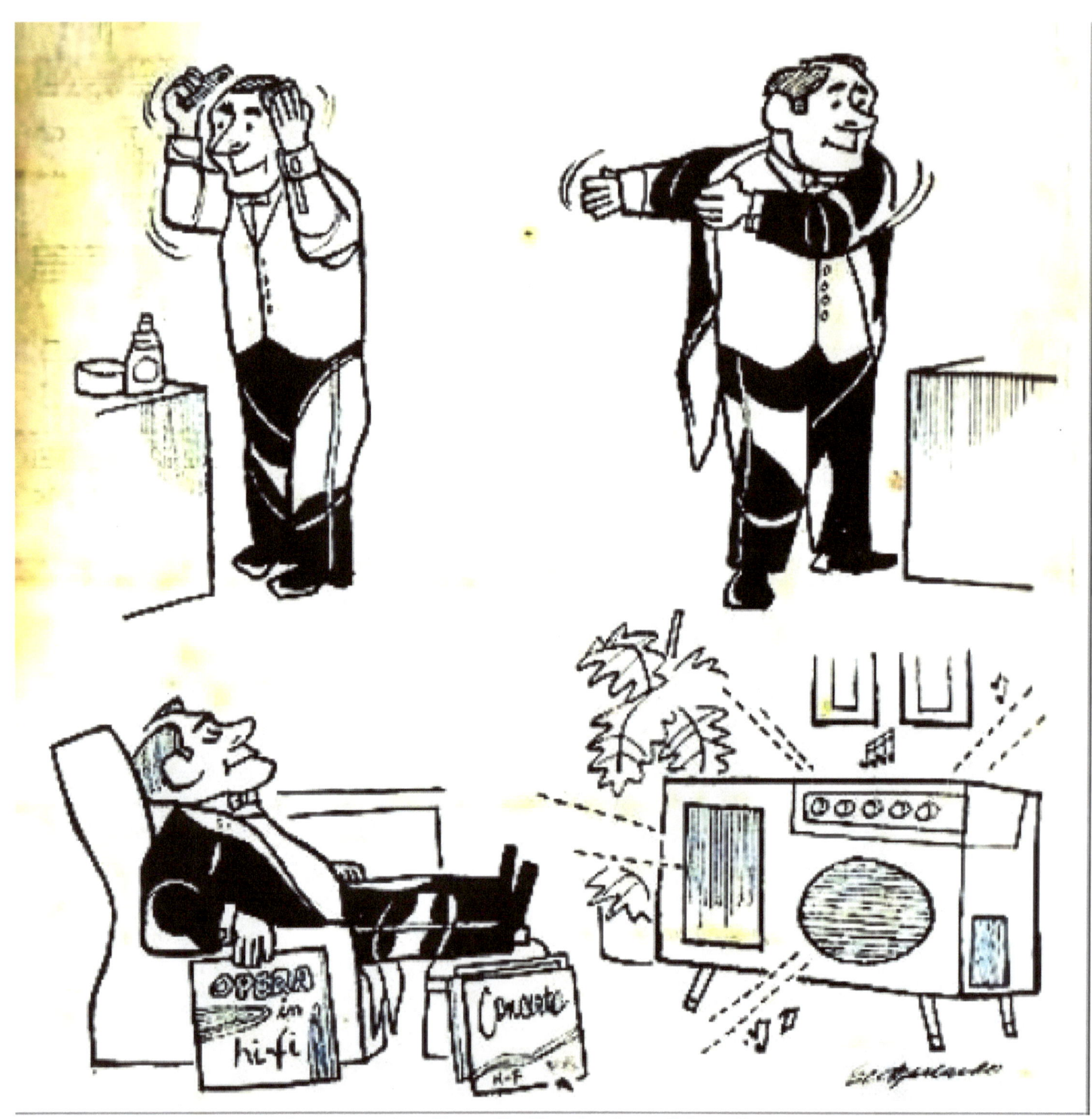

Funny Cartoon by Bert Gallardo (my friend), circa 1970s

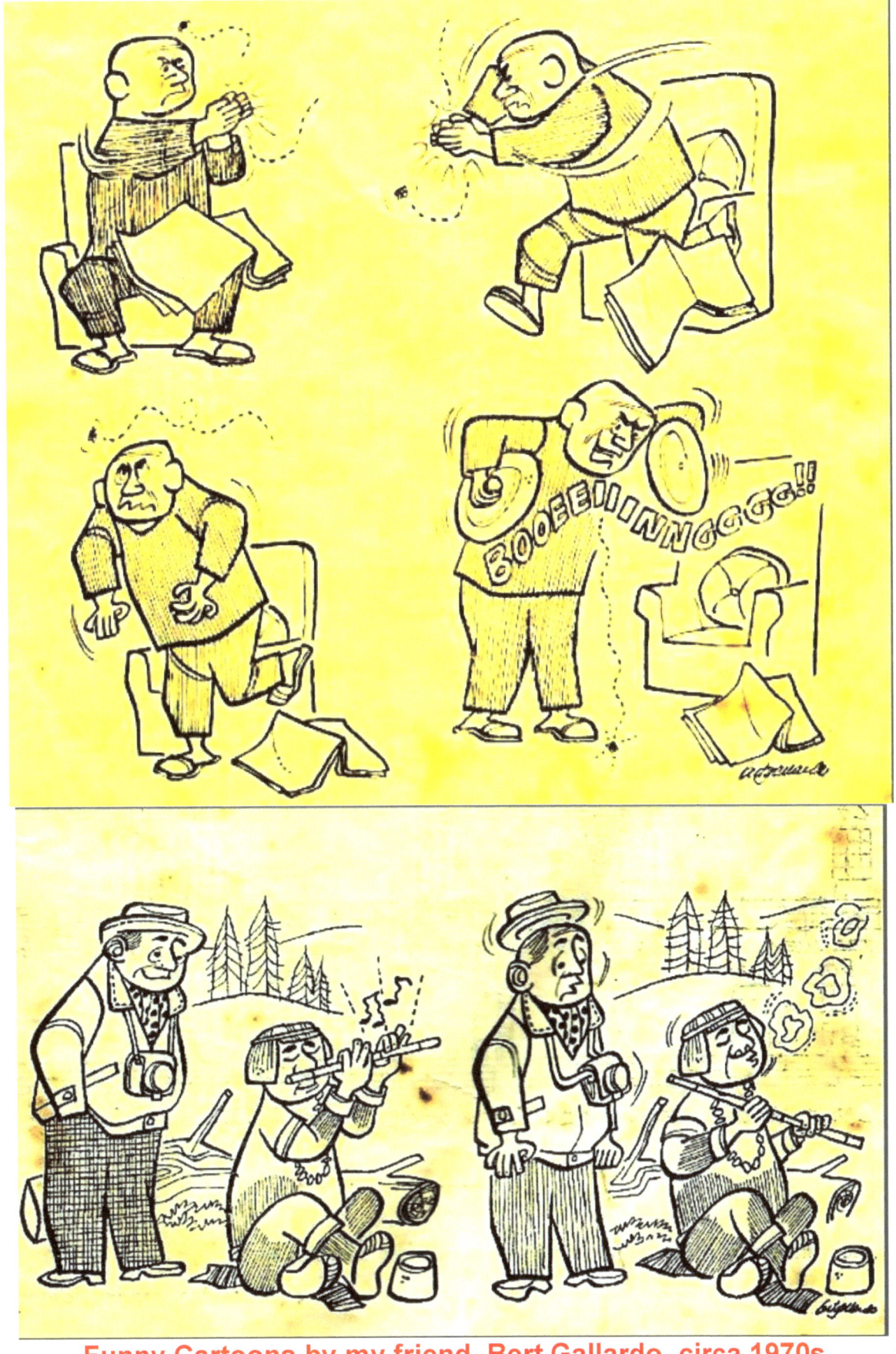

Funny Cartoons by my friend, Bert Gallardo, circa 1970s

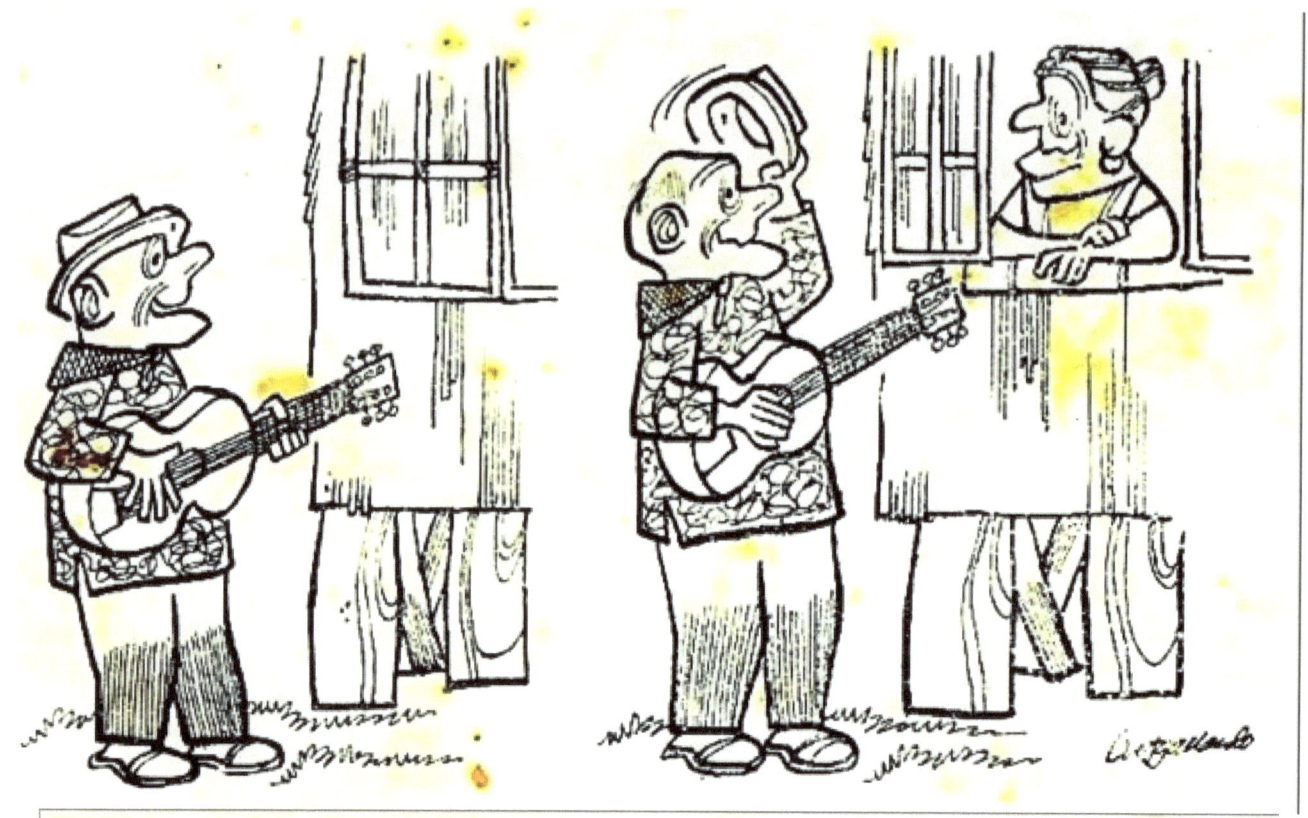

Funny Cartoons by my friend Bert Gallardo, circa 60s-70s

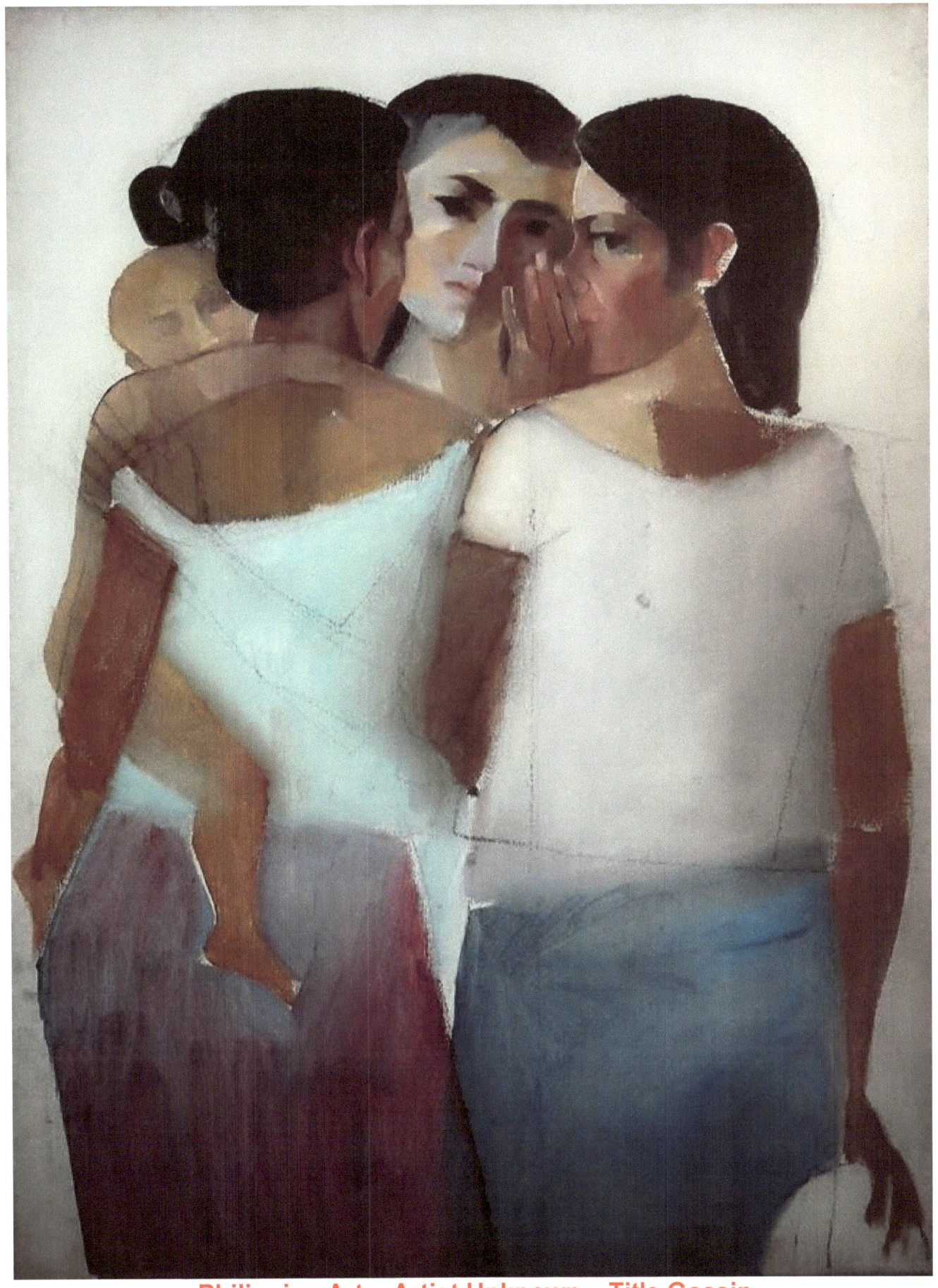

Philippine Art – Artist Unknown – Title Gossip

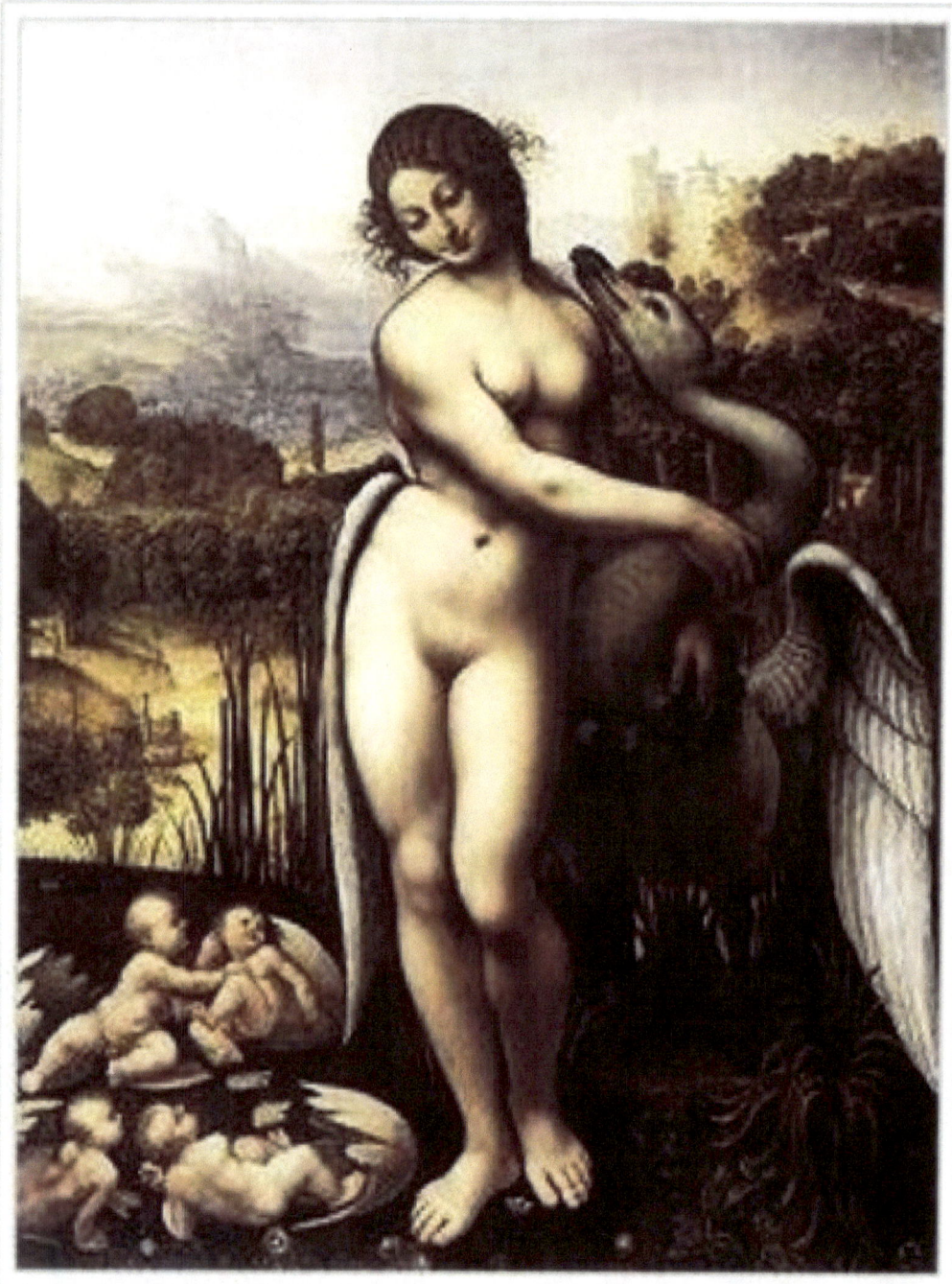

Leda and the Swan by Cesare da Sesto (c. 1506–1510, Wilton). The artist has been intrigued by the idea of Helen's unconventional birth; she and Clytemnestra are shown emerging from one egg; Castor and Pollux from another.

Old Masters painting

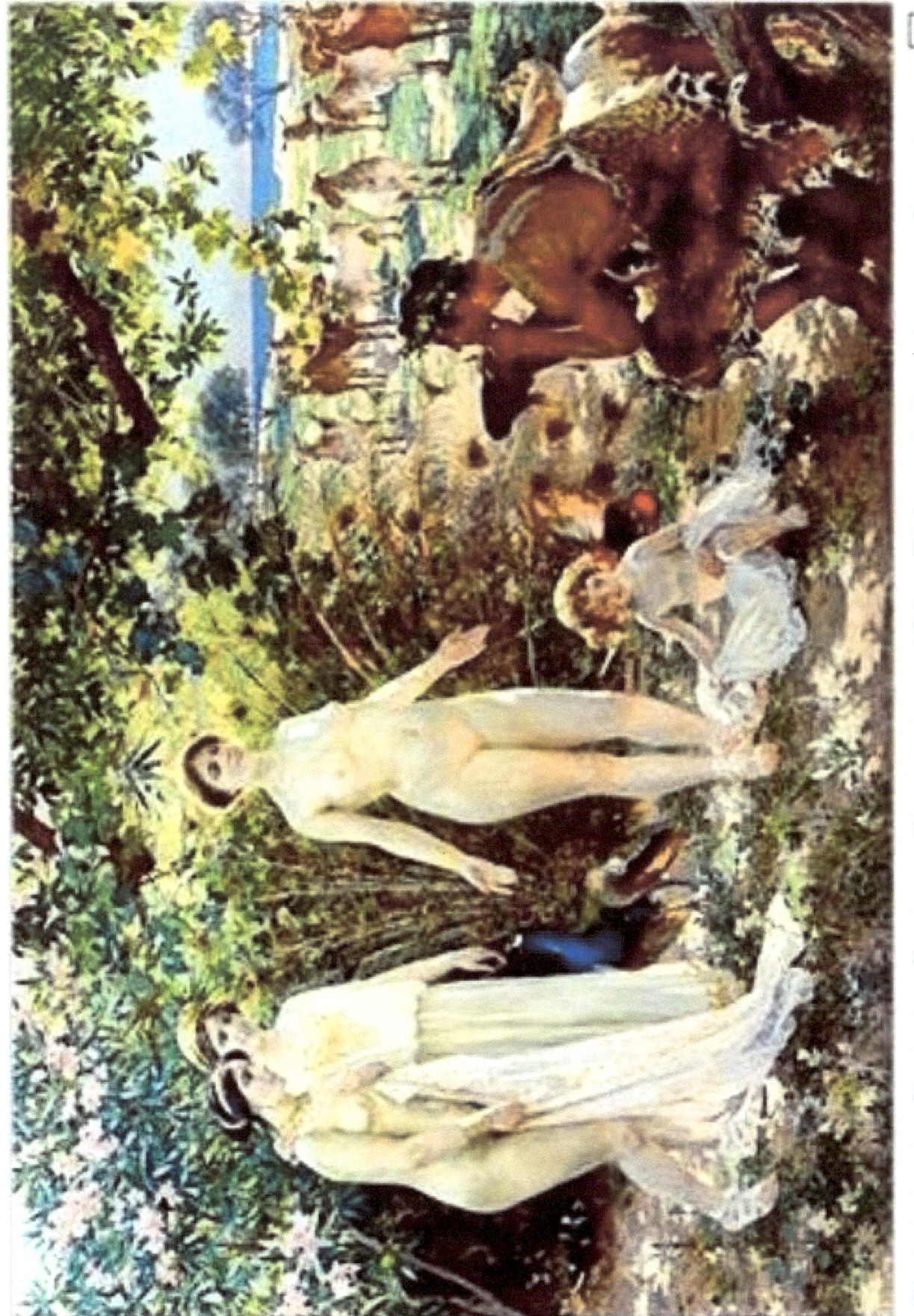

El Juicio de Paris by Enrique Simonet, c. 1904. This painting depicts Paris' judgement. He is inspecting Aphrodite, who is standing naked before him. Hera and Athena watch nearby.

Old Masters, Artist unknown

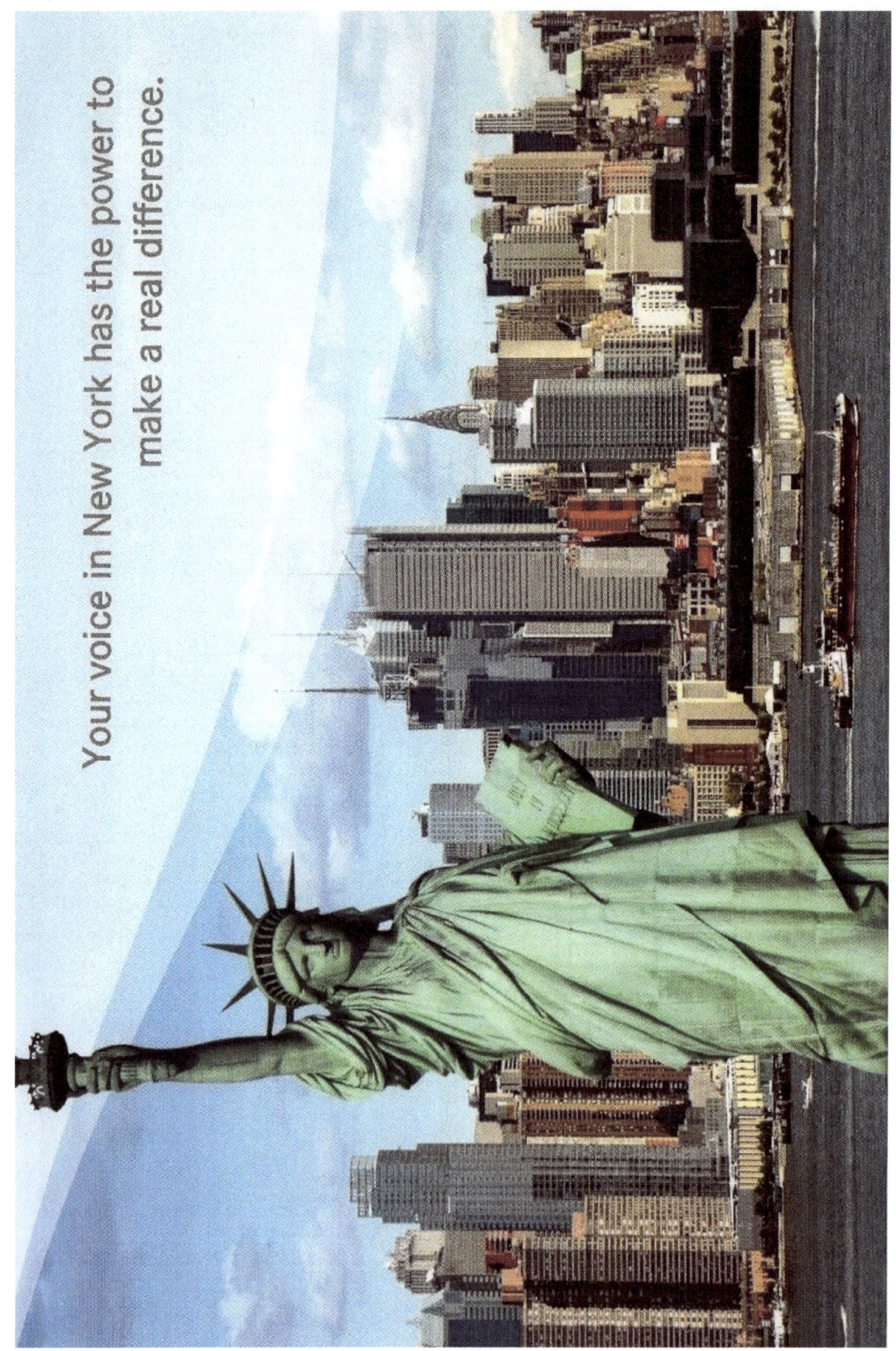

Favorite American Icon or Image

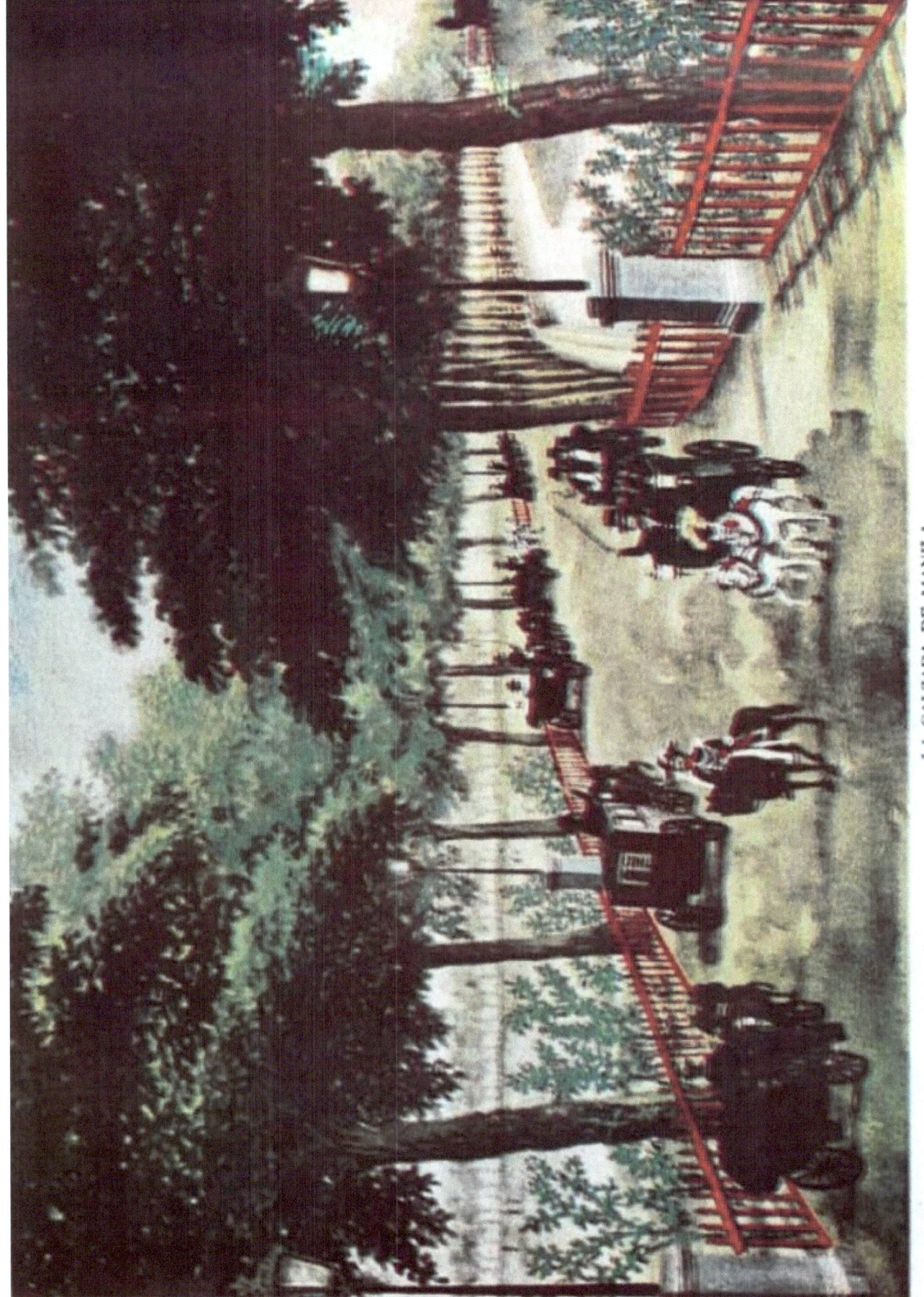

LA CALZADA DE MANILA

The Calzada (the present Bonifacio Drive) was to the Manila of 1860 dan to Calcutta. It was the afternoon gathering-place of Manila's world of what Hyde Park was to London, the Champs Elysées to Paris and the Mei- fashion. Twice a week, a native band gave concerts for the promenaders.

Old Philippine Art – Streets of Manila

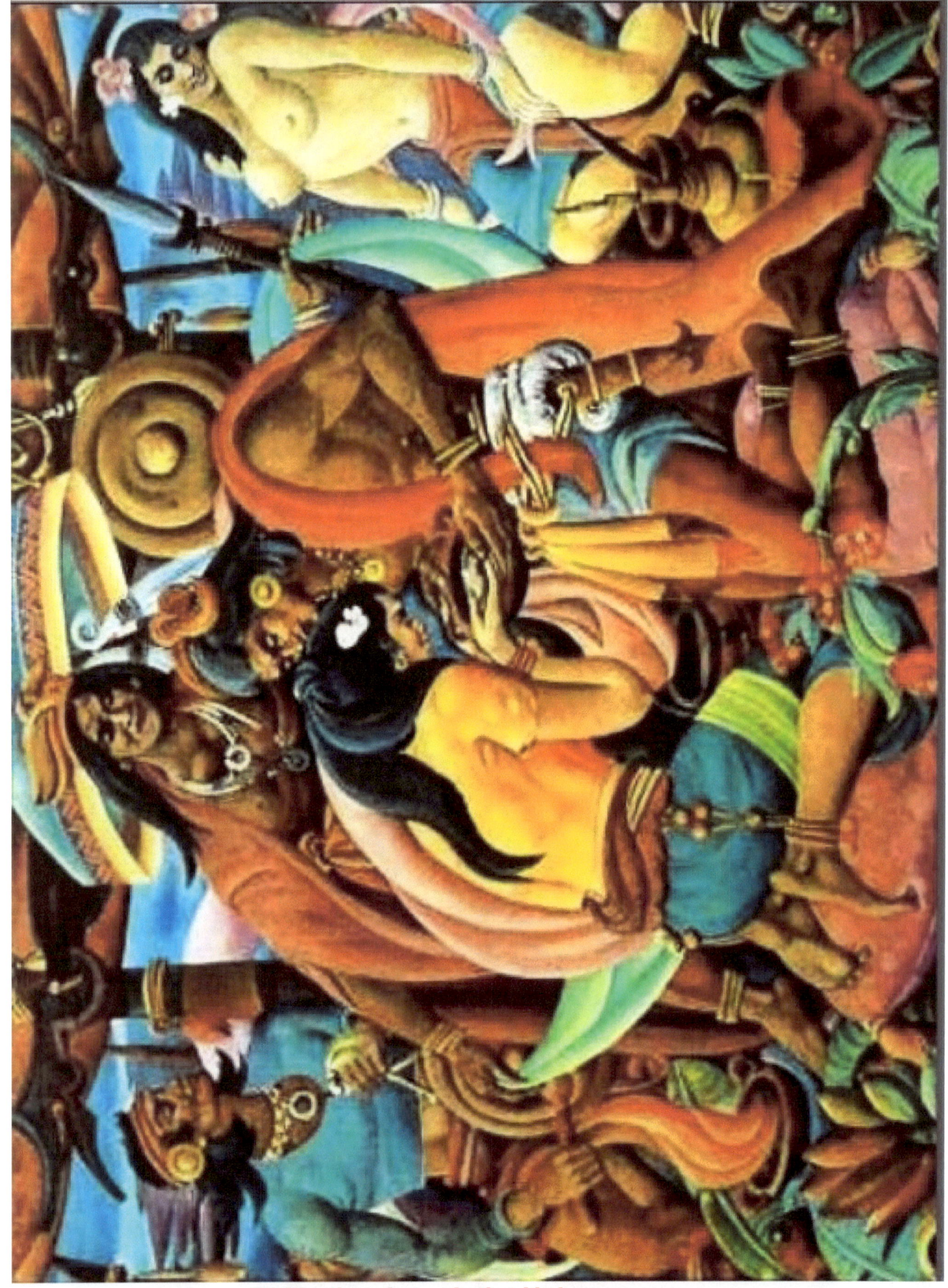

Philippine Art – Artist Unknown, new

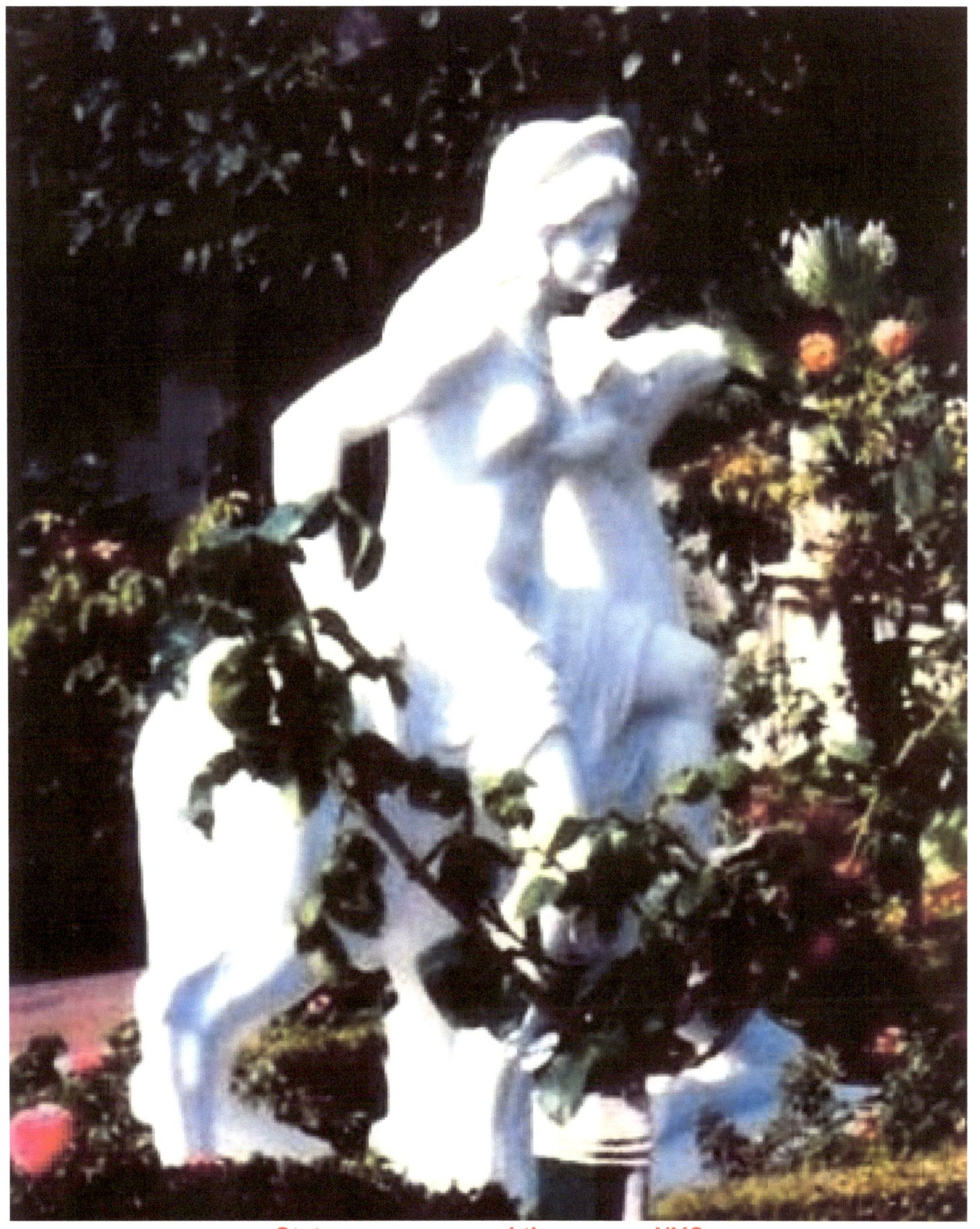

Stataue seen around the corner, NYC

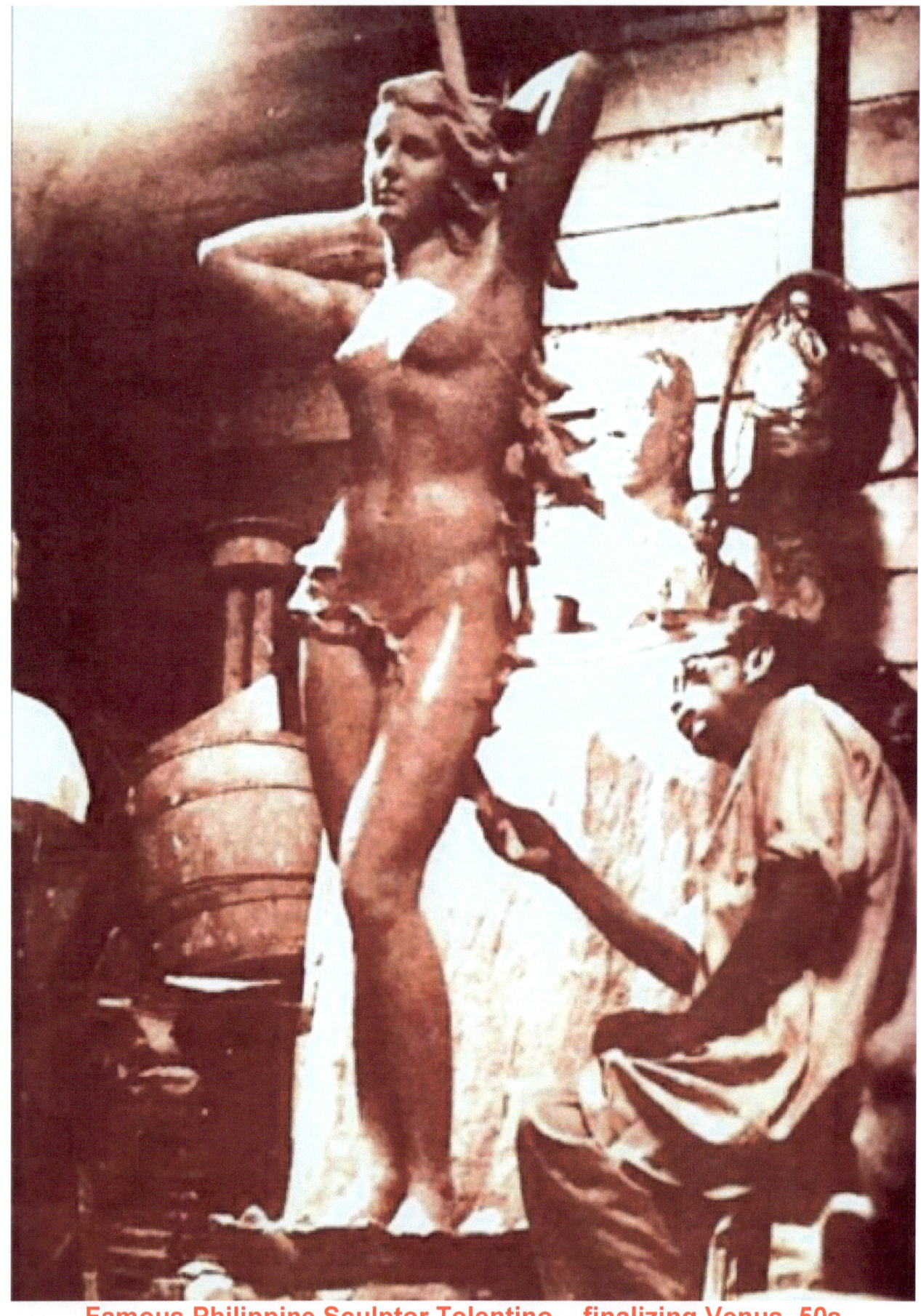

Famous Philippine Sculptor Tolentino – finalizing Venus, 50s

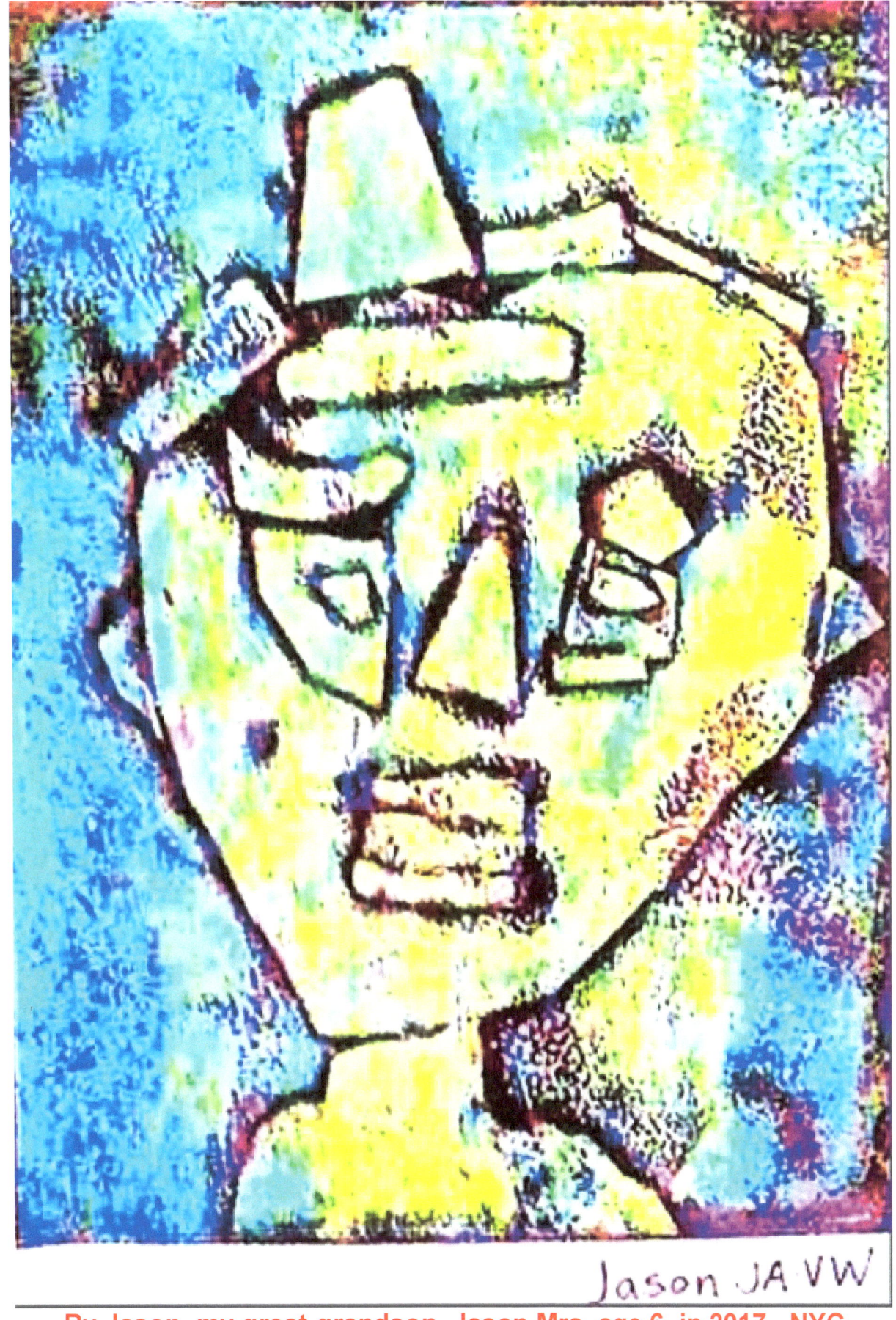

By Jason, my great-grandson, Jason Mra, age 6, in 2017, NYC

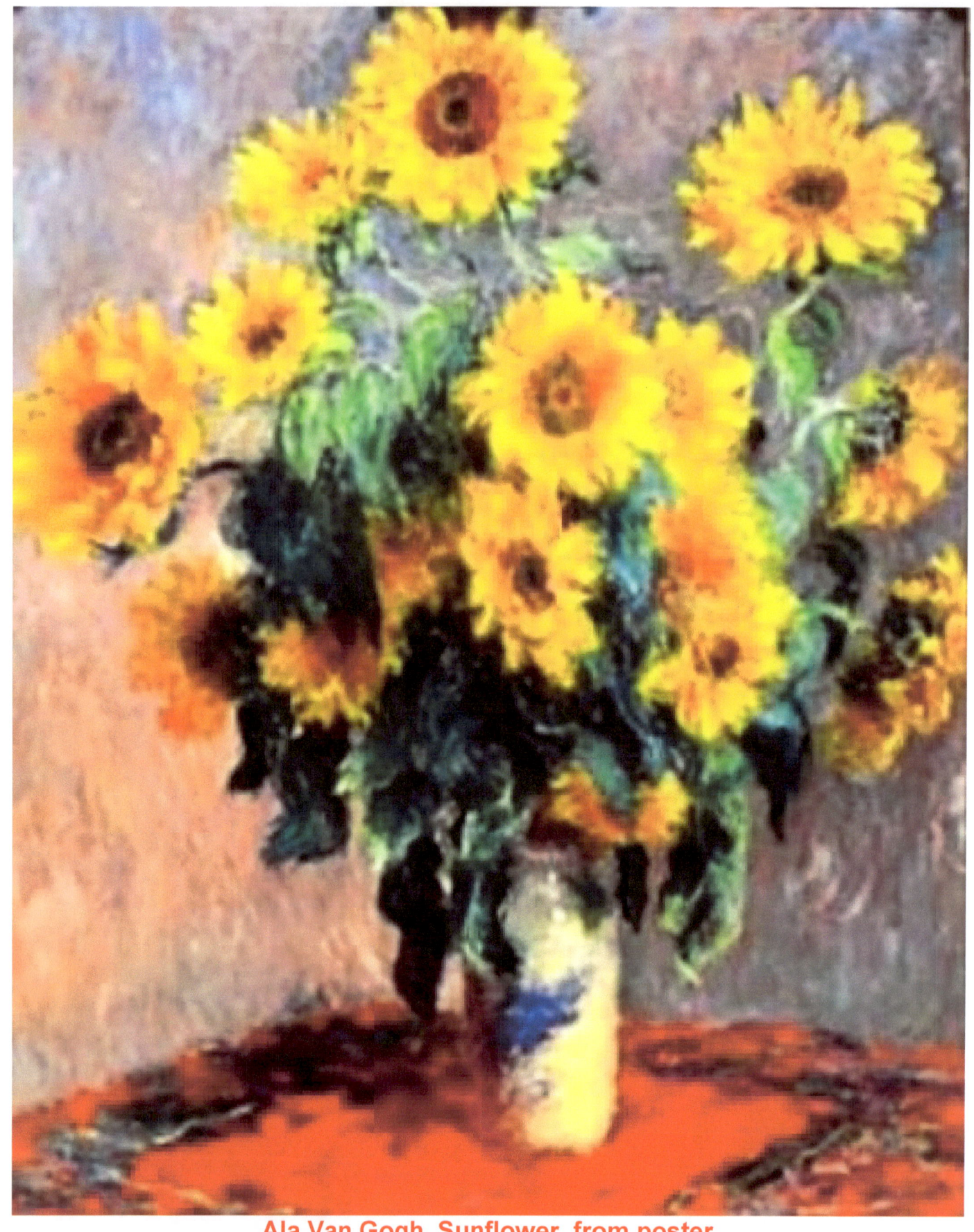

Ala Van Gogh, Sunflower, from poster

A Renoir, old masters painting

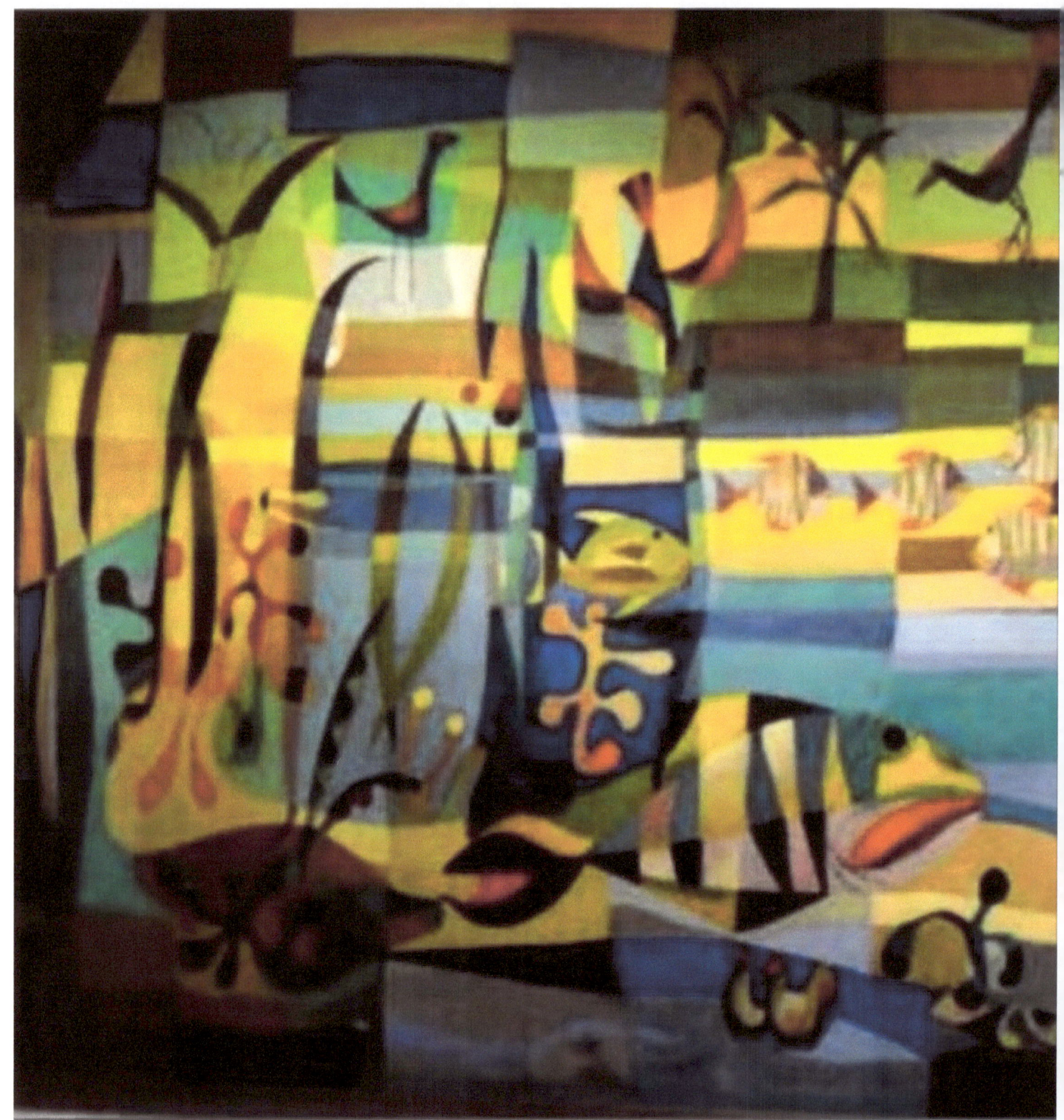

A Vicente Manansala – Fish – 70s

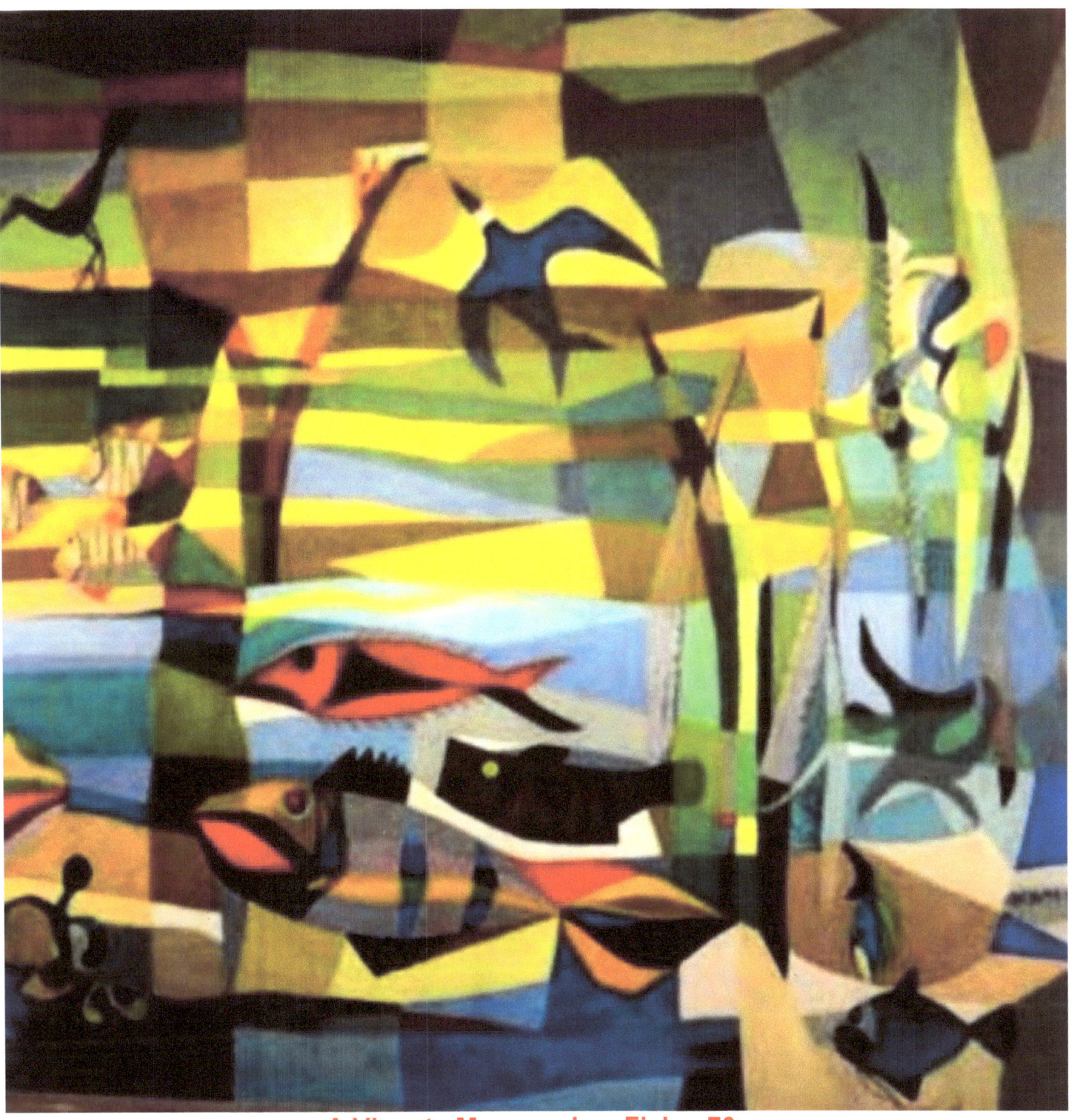

A Vicente Manansala – Fish – 70s

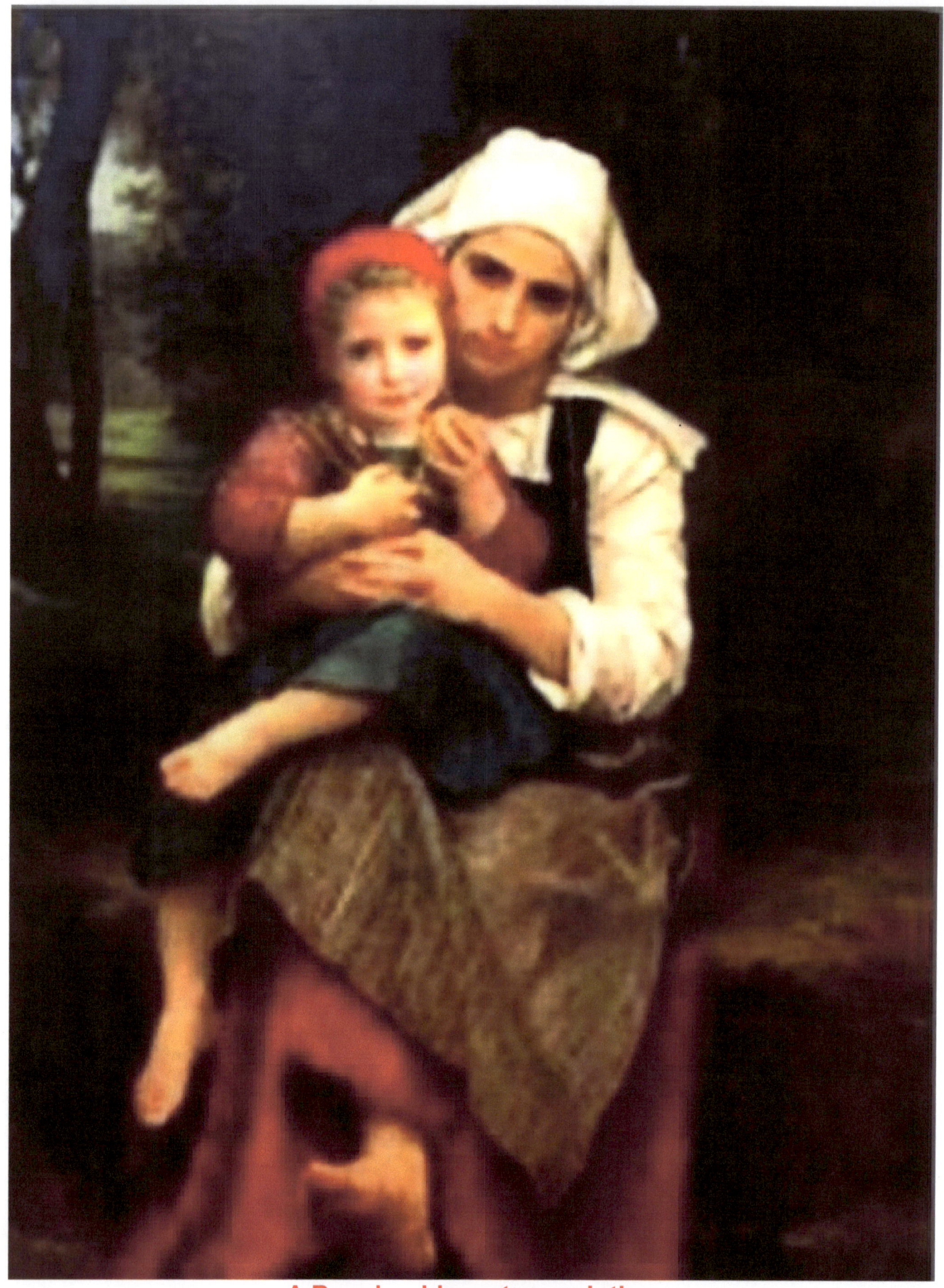

A Renoir, old masters painting

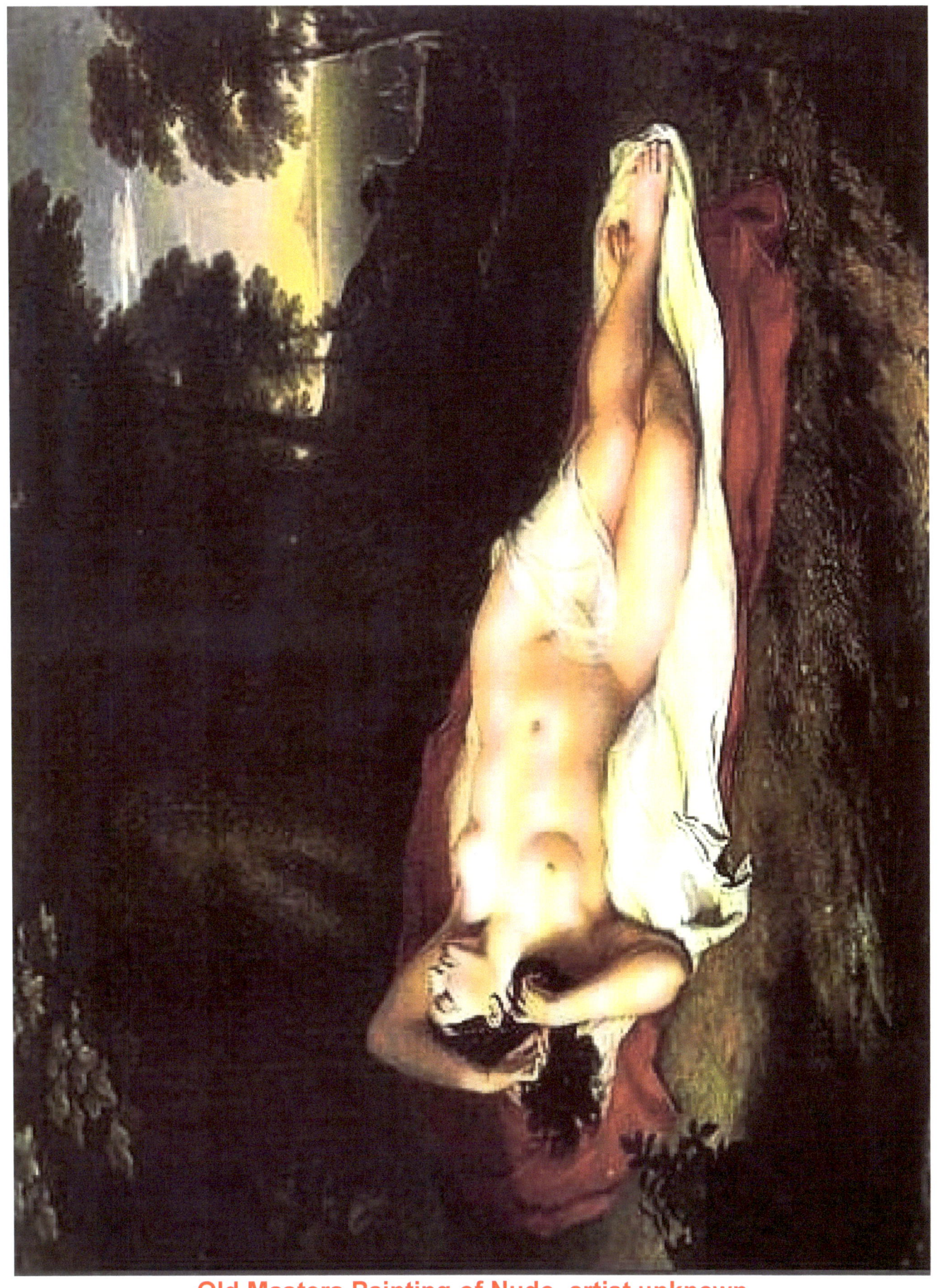

Old Masters Painting of Nude, artist unknown

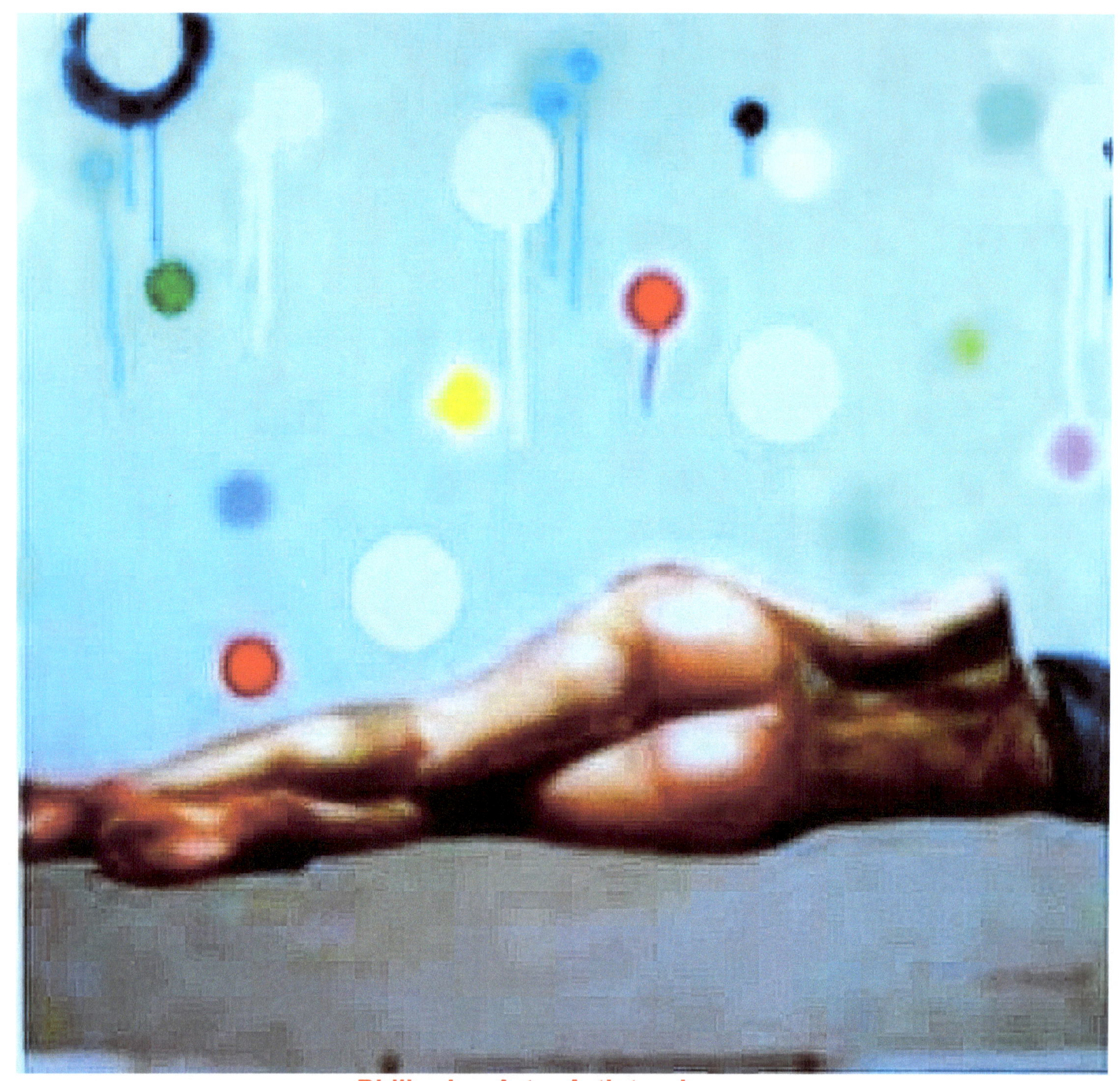

Philippina Art – Artist unknown

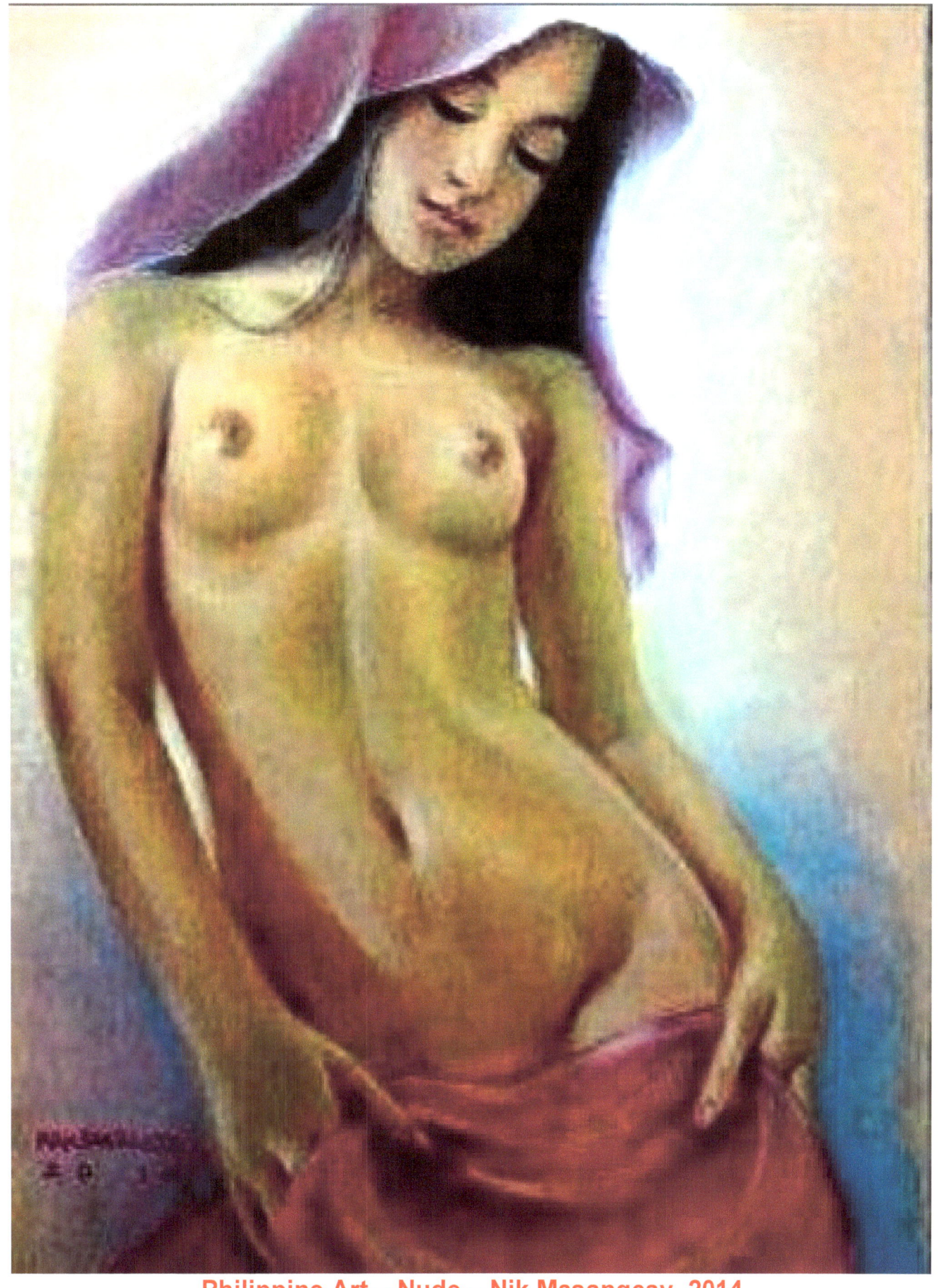

Philippine Art – Nude – Nik Masangcay, 2014

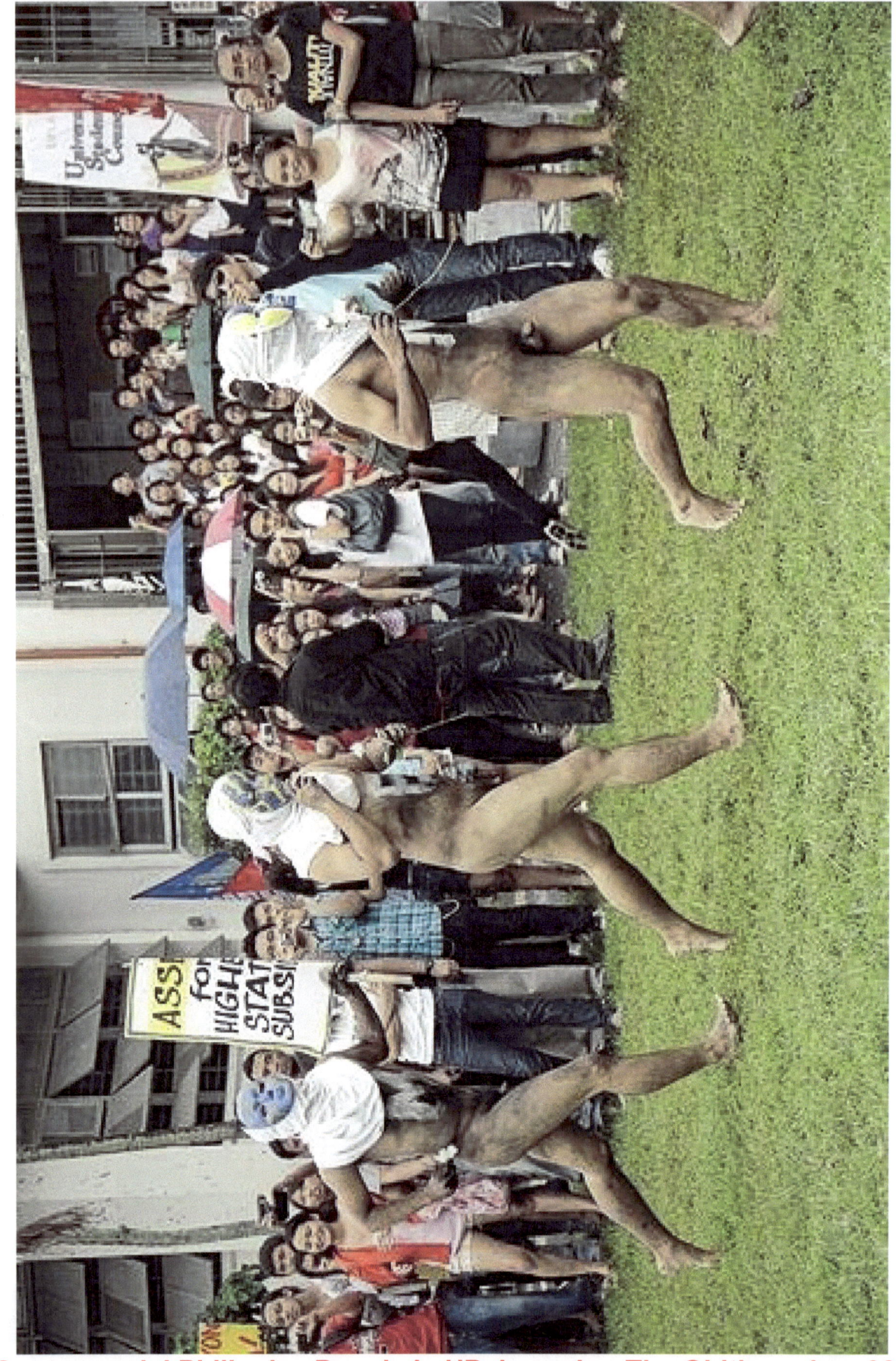

Controversial Philippine Parade in UP, honoring The Obltion, circa 90s

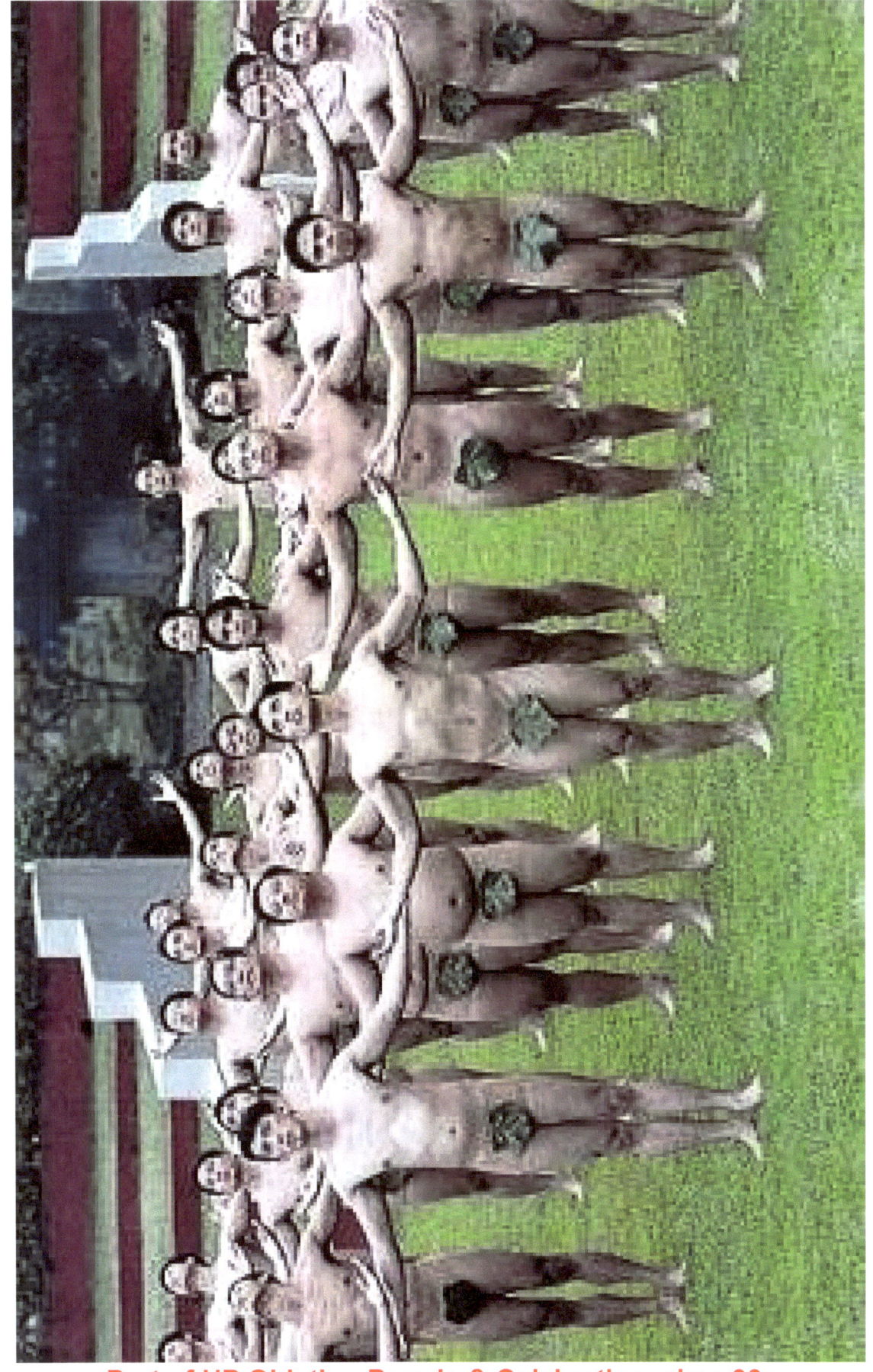

Part of UP Oblation Parade & Celebration, circa 90s

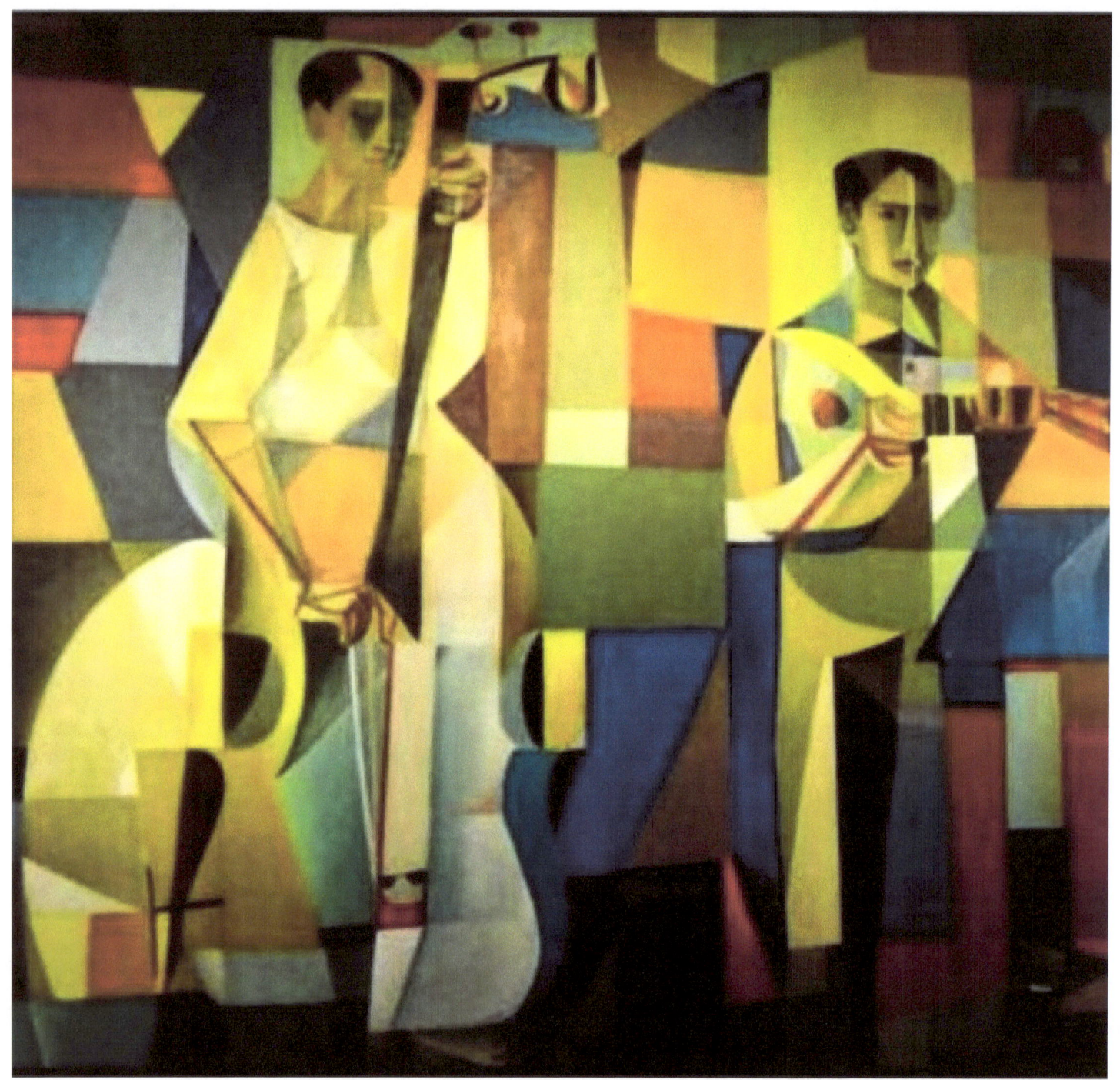

A Vicente Manansala – strings, circa 70s

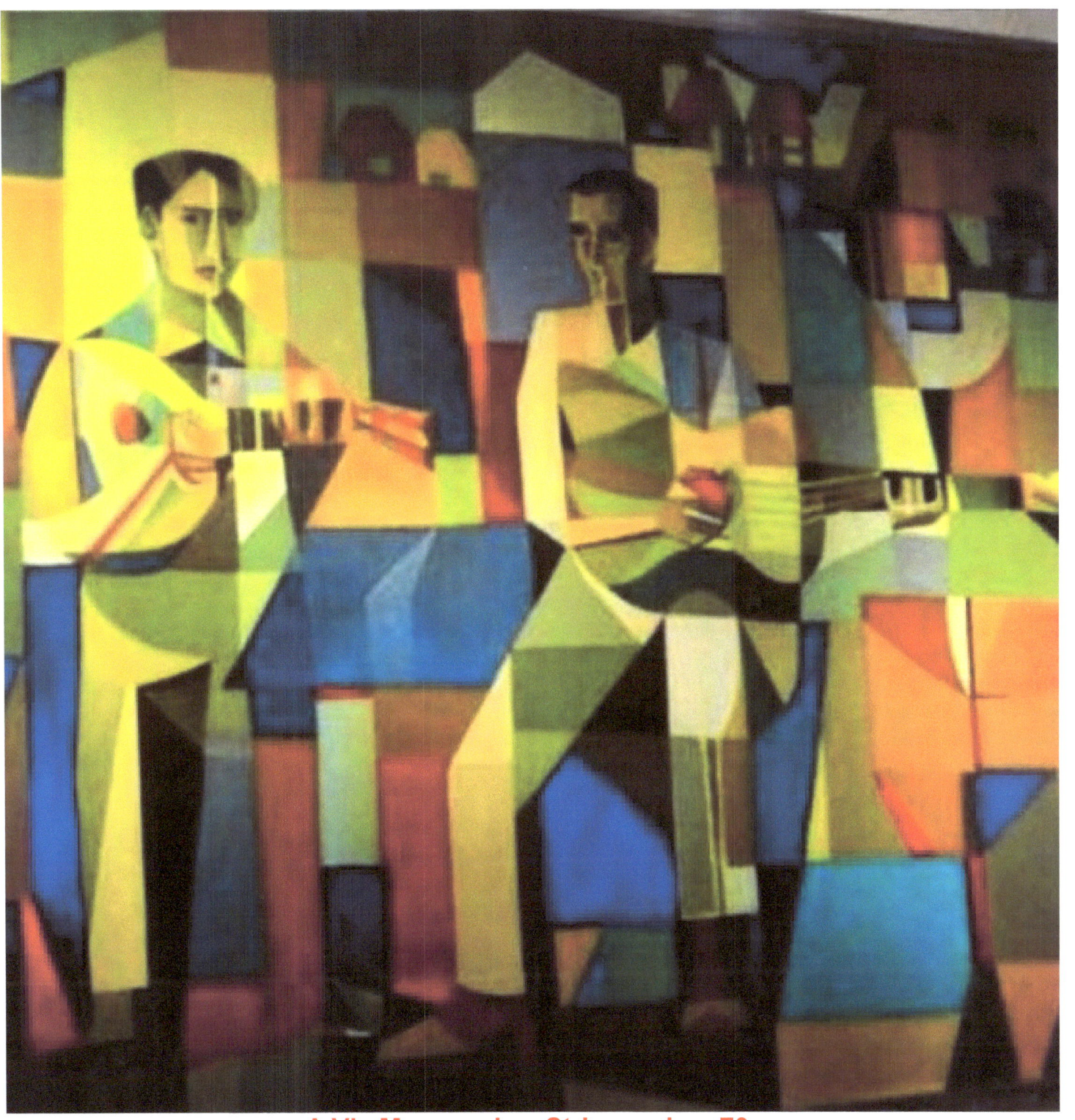

A Vic Manansala – Strings, circa 70s

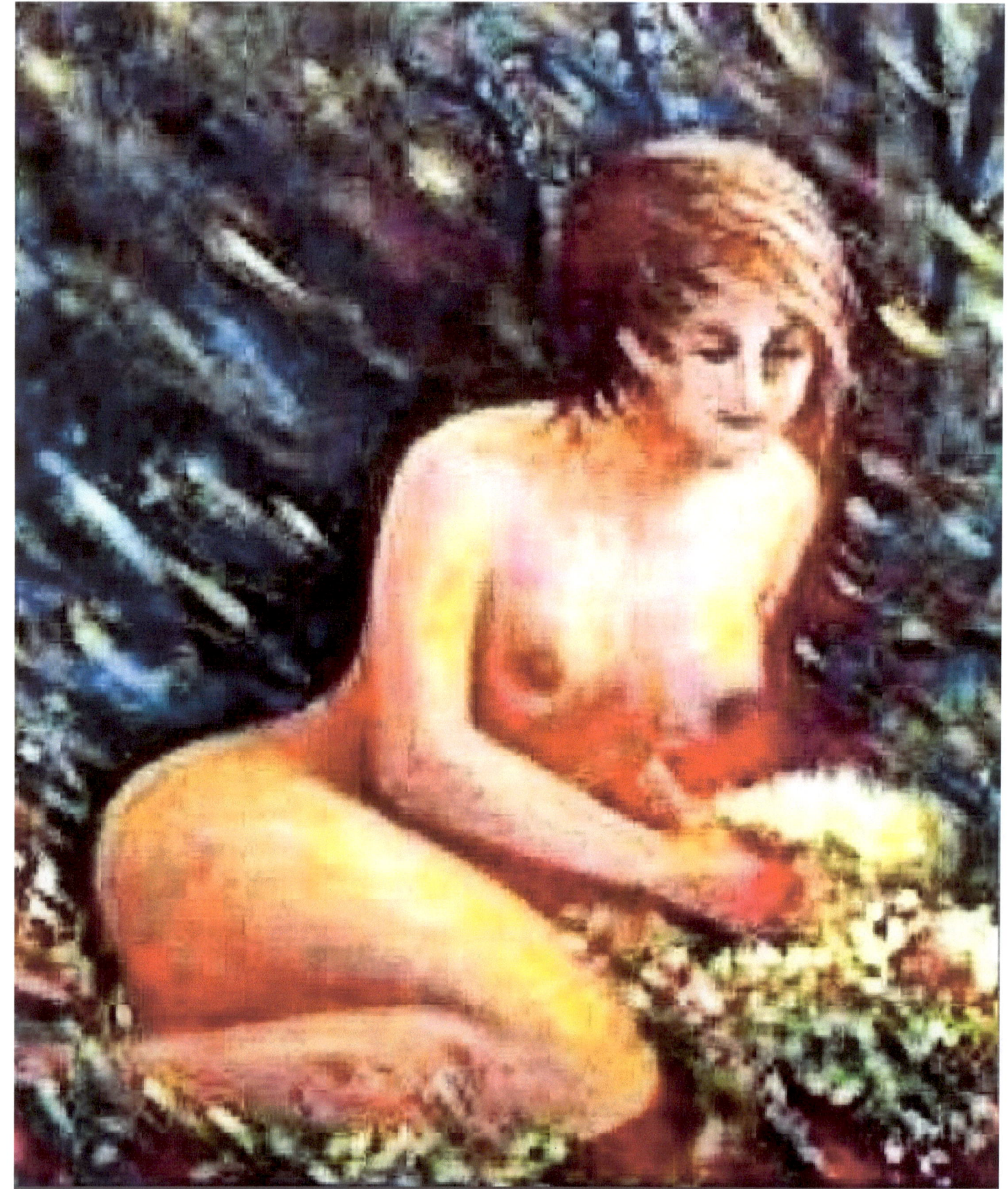

A Joeyboi Painting – nude

Tatayjobo pic – distorted online artwork

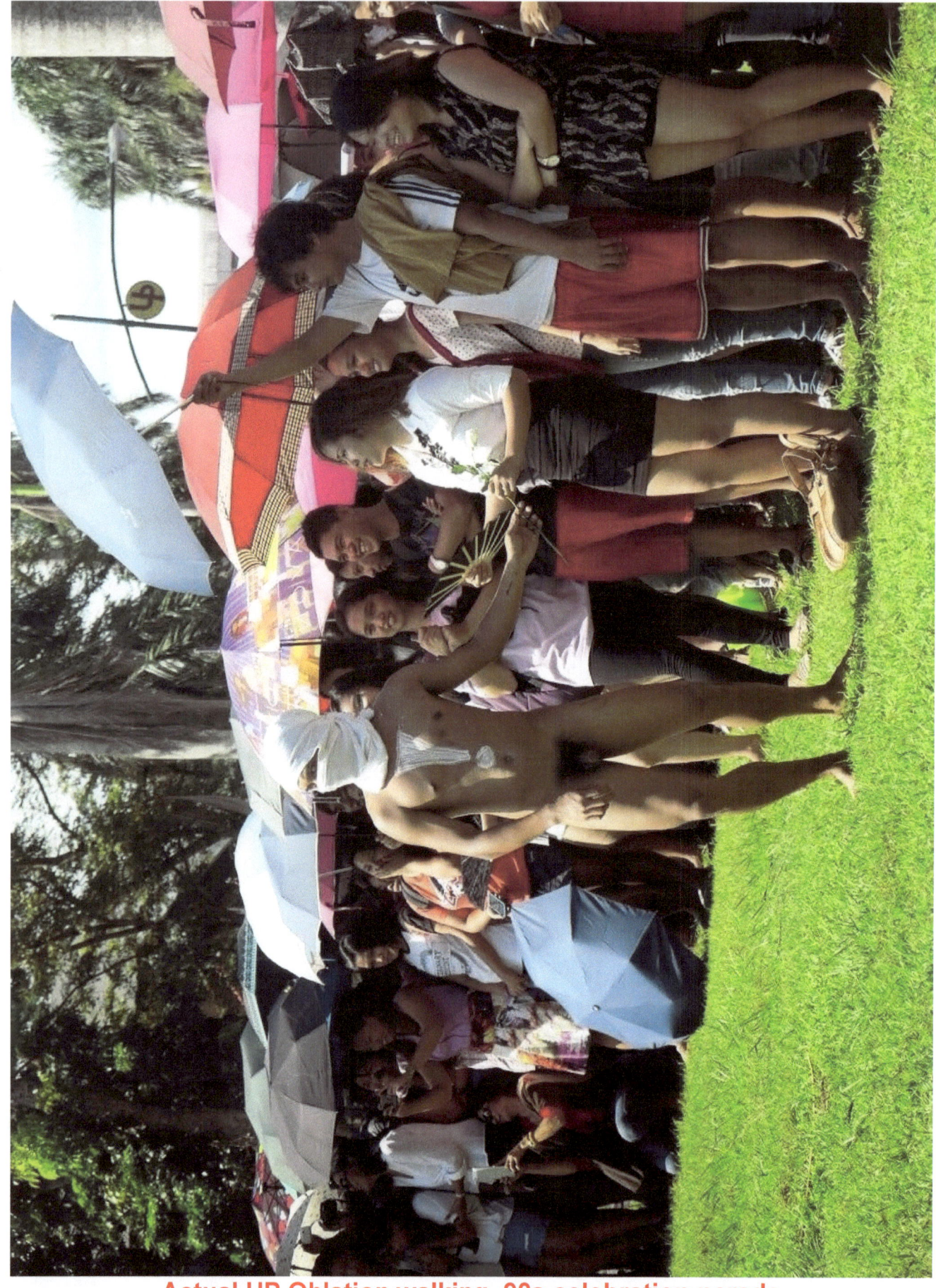
Actual UP Oblation walking, 90s celebration parade

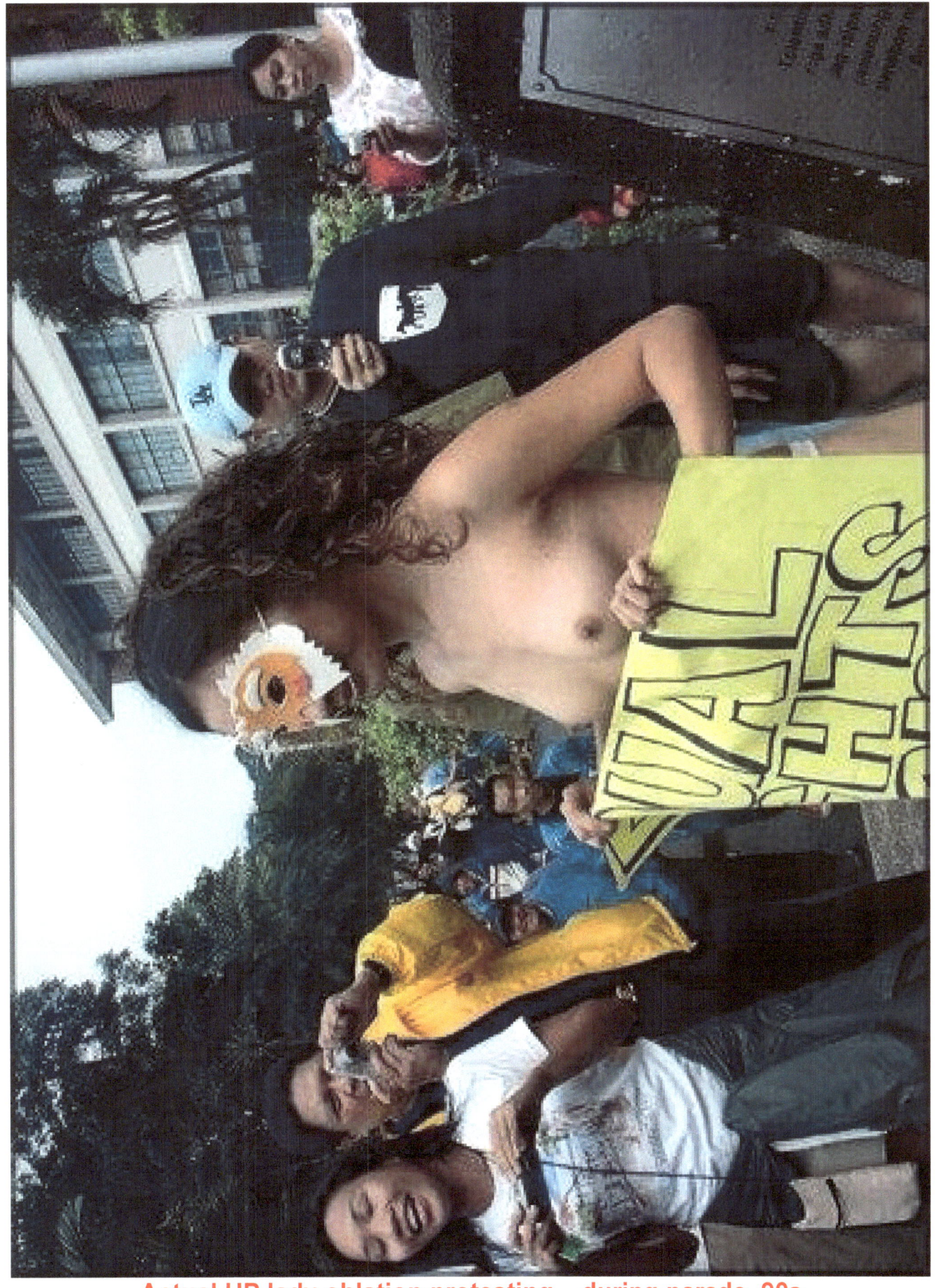

Actual UP lady oblation protesting – during parade, 90s

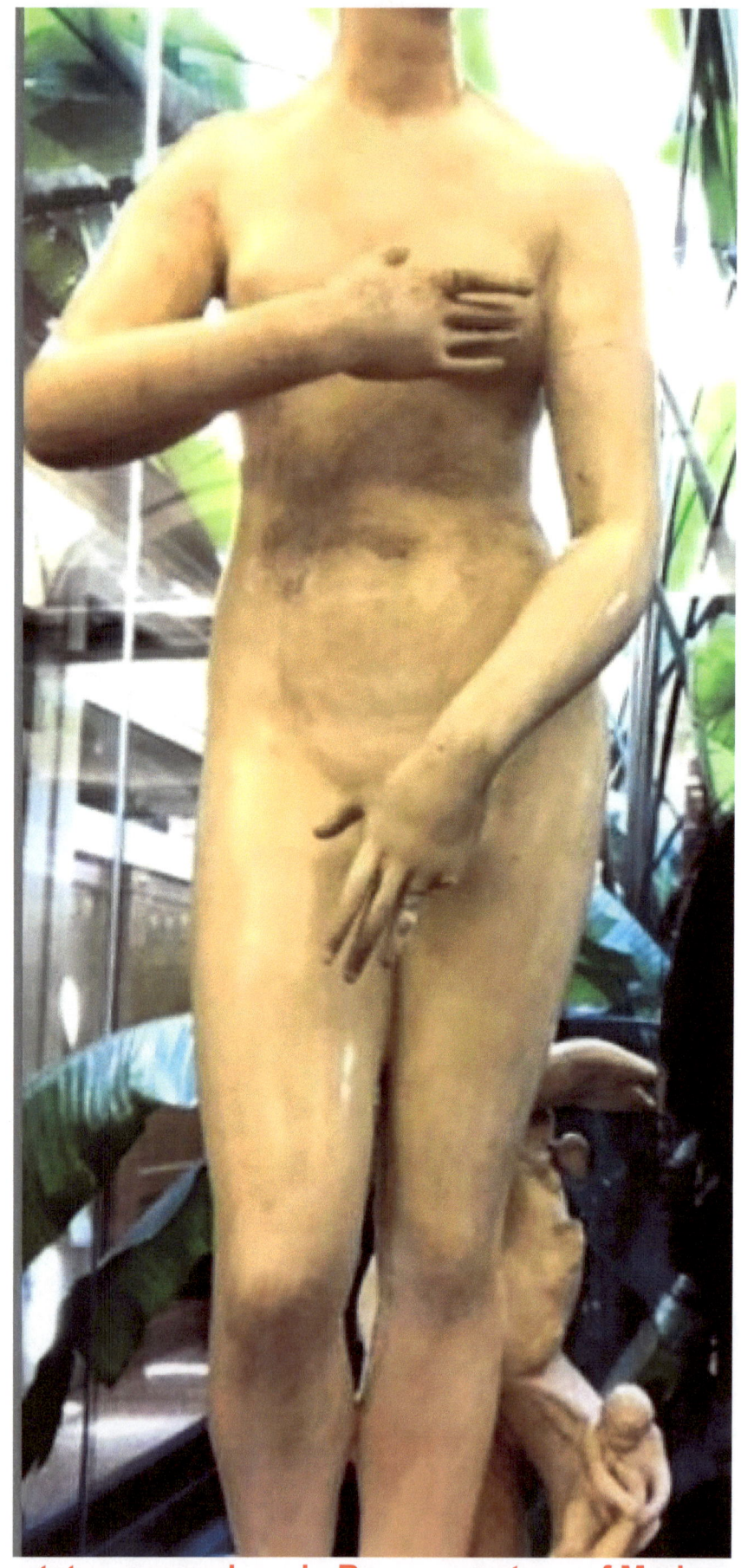

A Nude statue somewhere in Rome, courtesy of Maricar Jamito

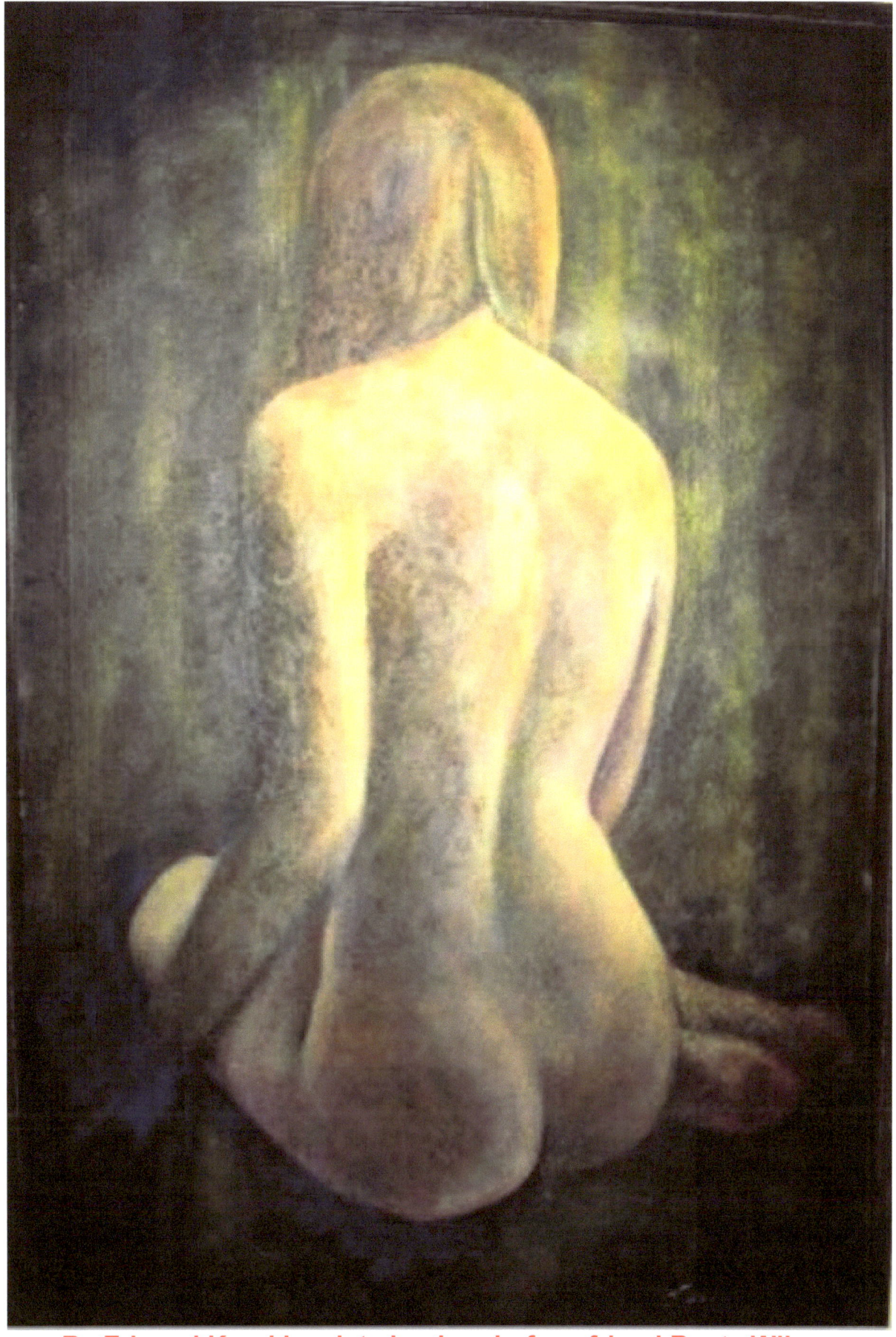

By Edward Kareklas, late husband of my friend Boots Wilson

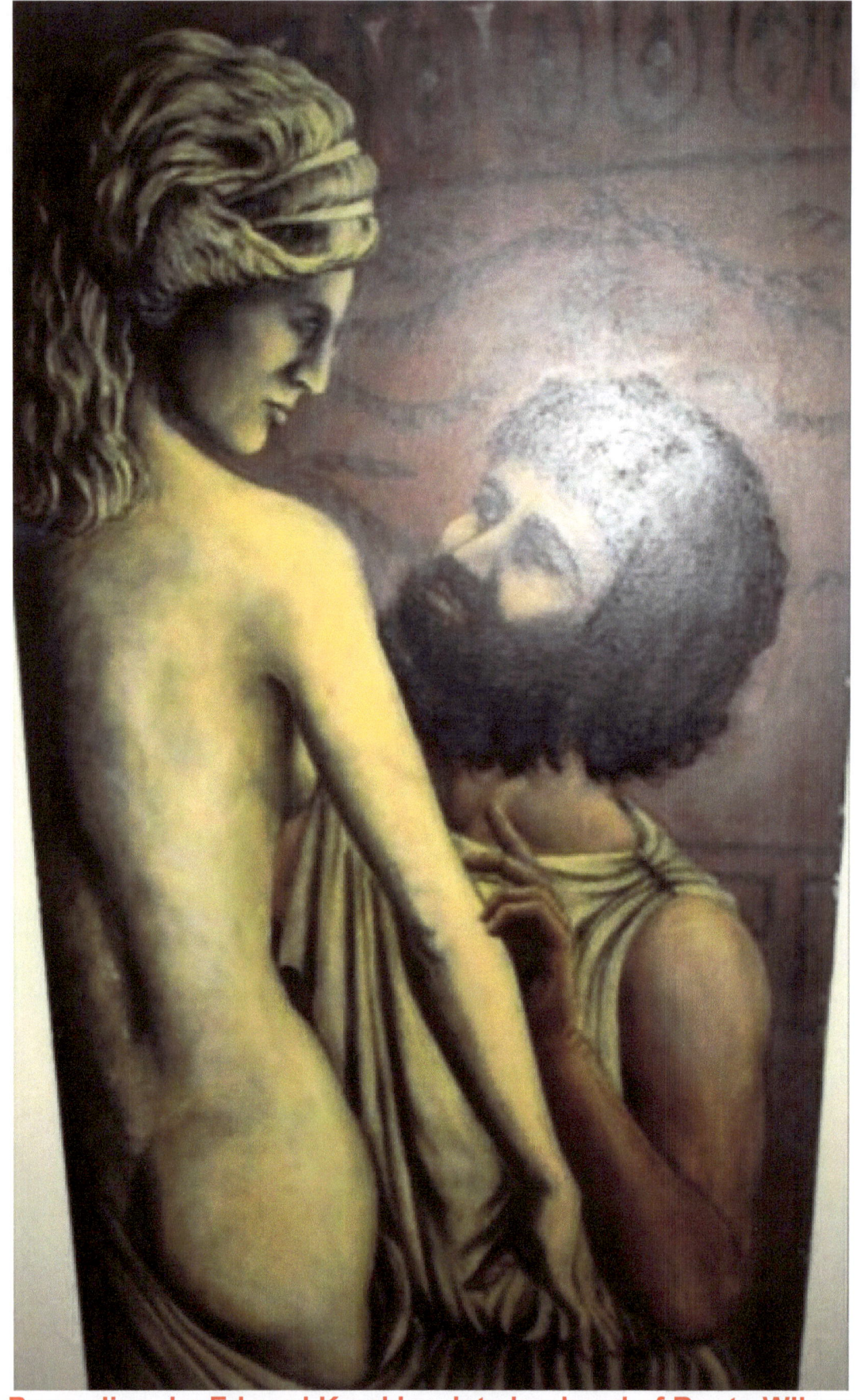

Pygmalion, by Edward Kareklas, late husband of Boots Wilson

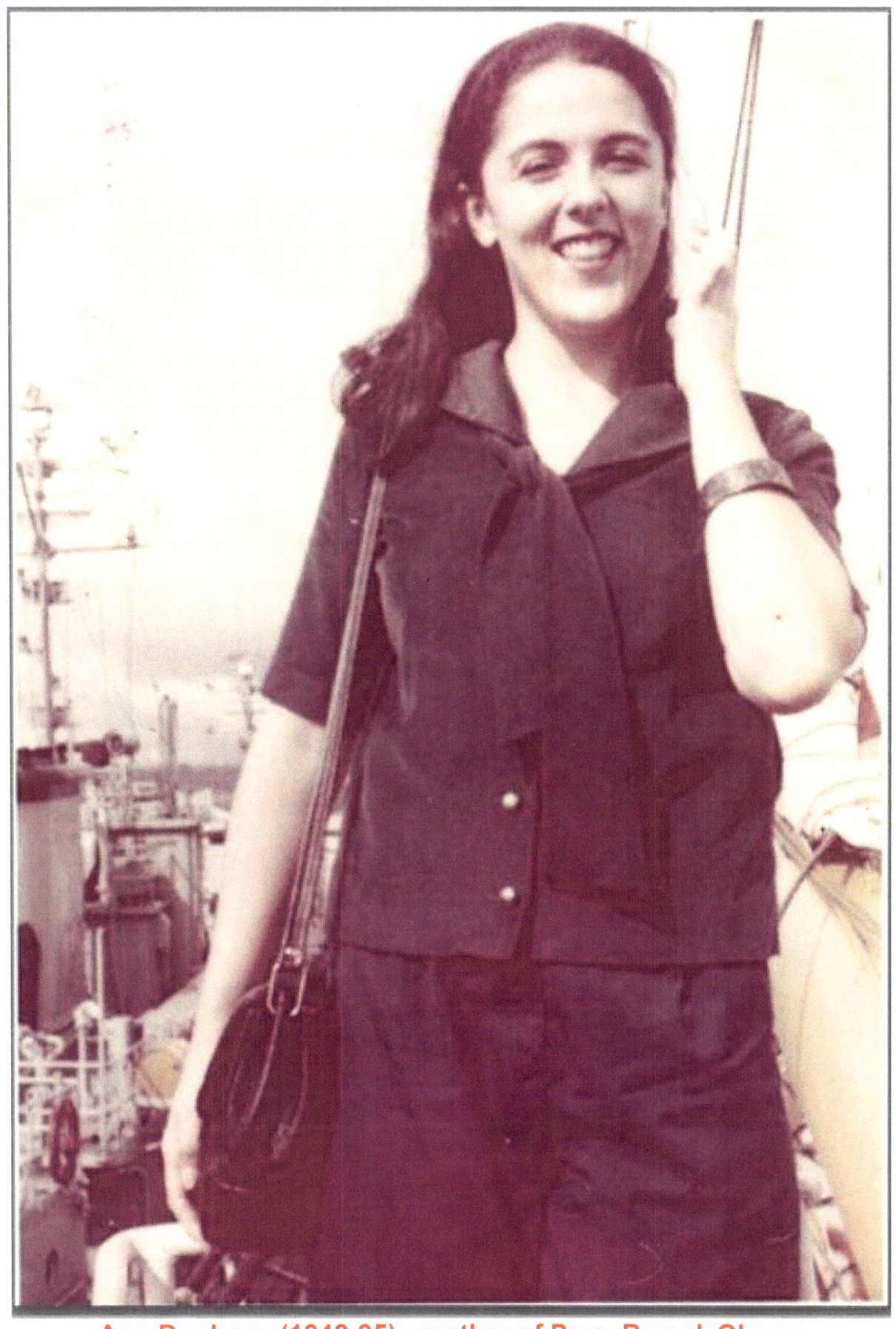

Ann Dunham, (1942-95), mother of Pres. Barack Obama

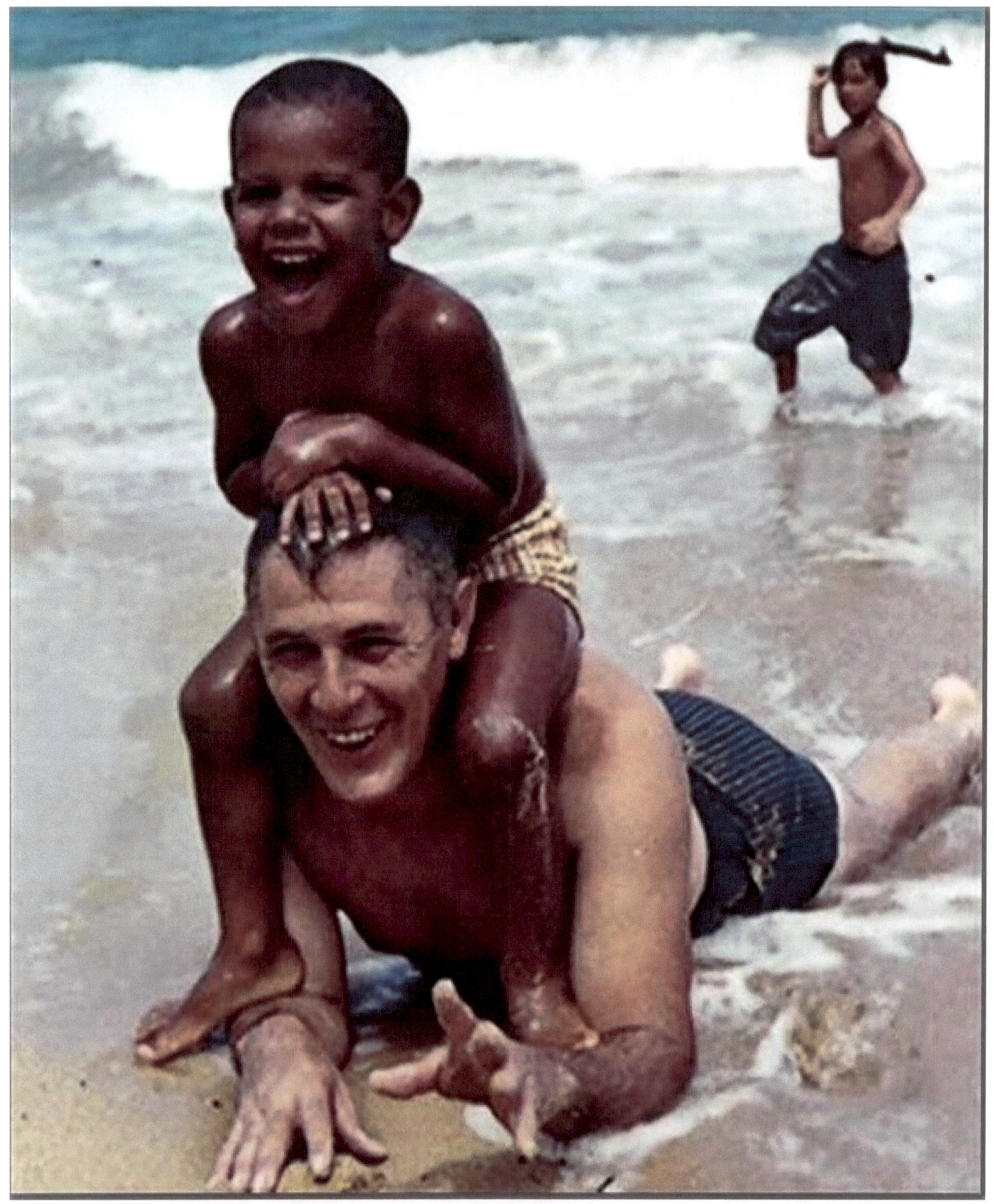

Young Barack Obama with his grandpa, Stanley Dunham, 1918-92

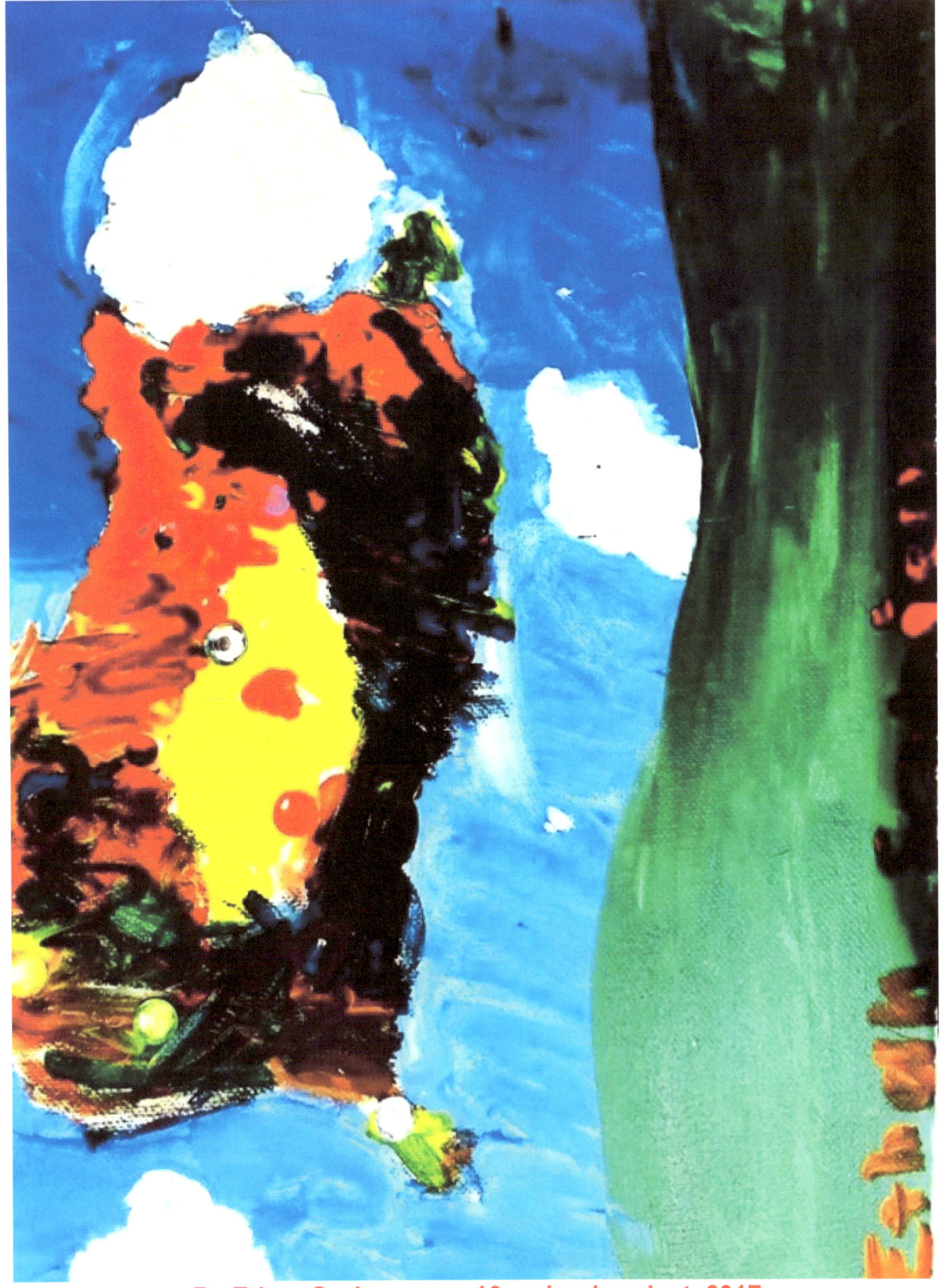

By Ethan Soriano, age 10, school project, 2017

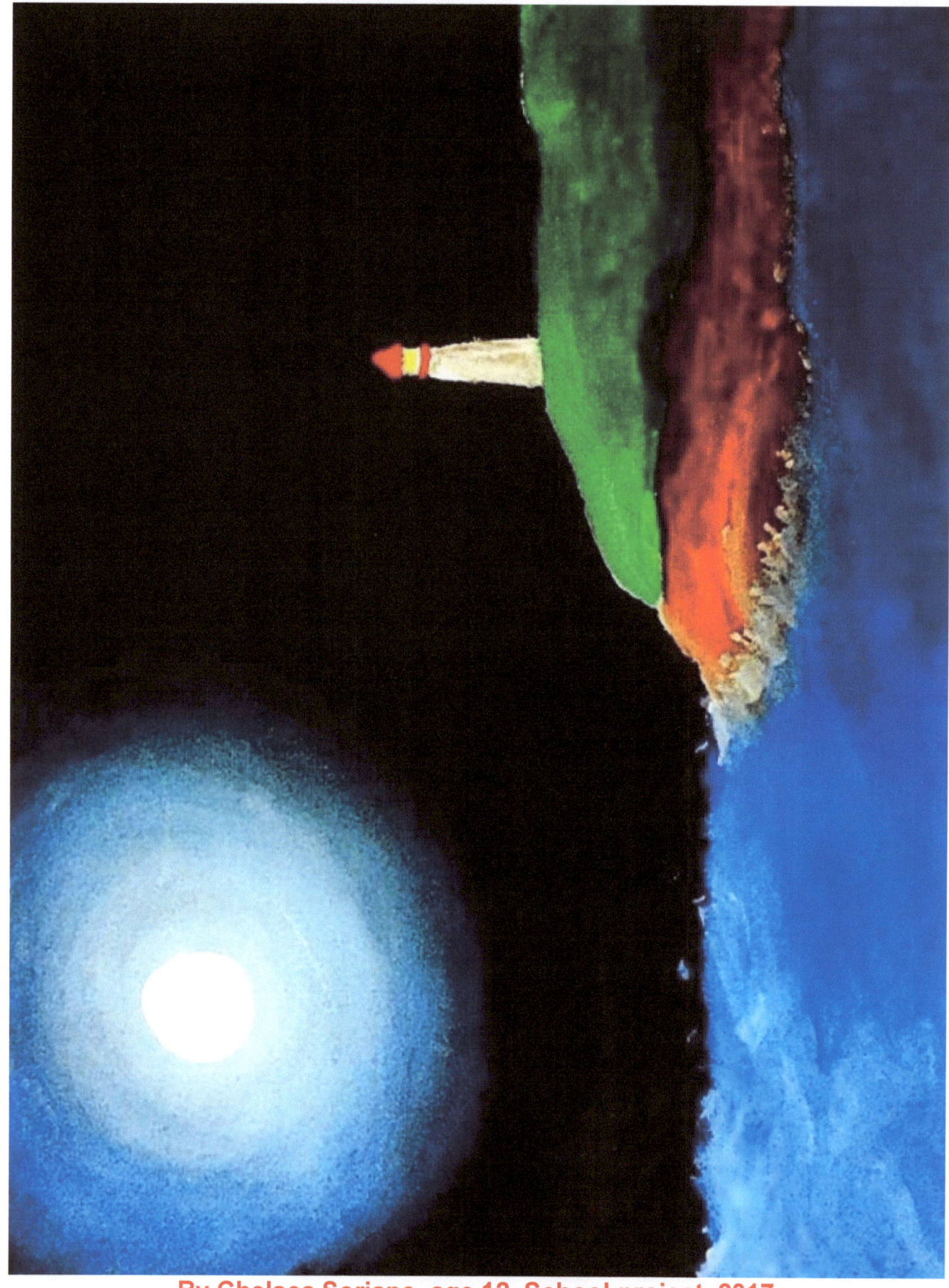

By Chelsea Soriano, age 12. School project, 2017

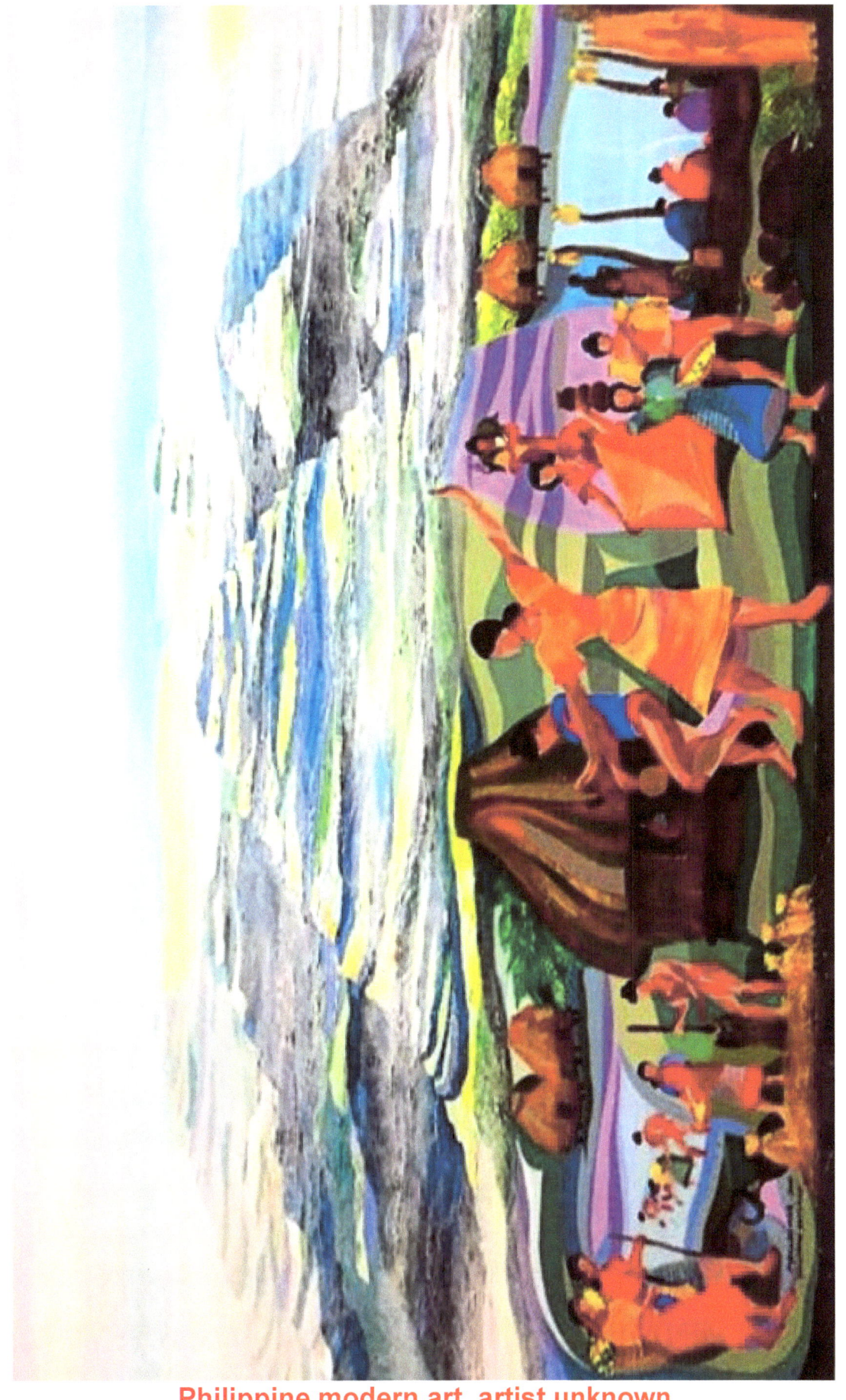

Philippine modern art, artist unknown

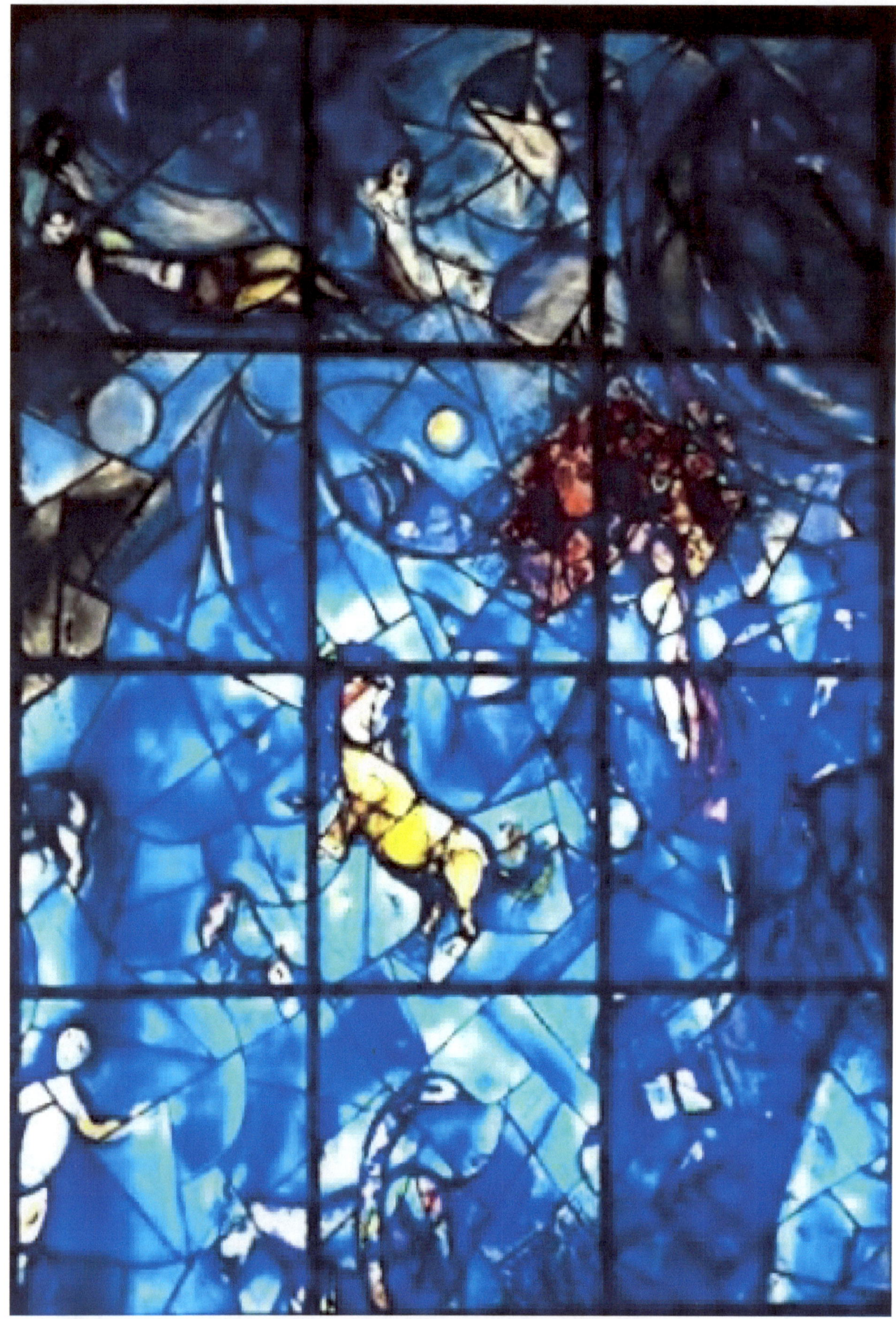

U.N. Frosted Glass window Display

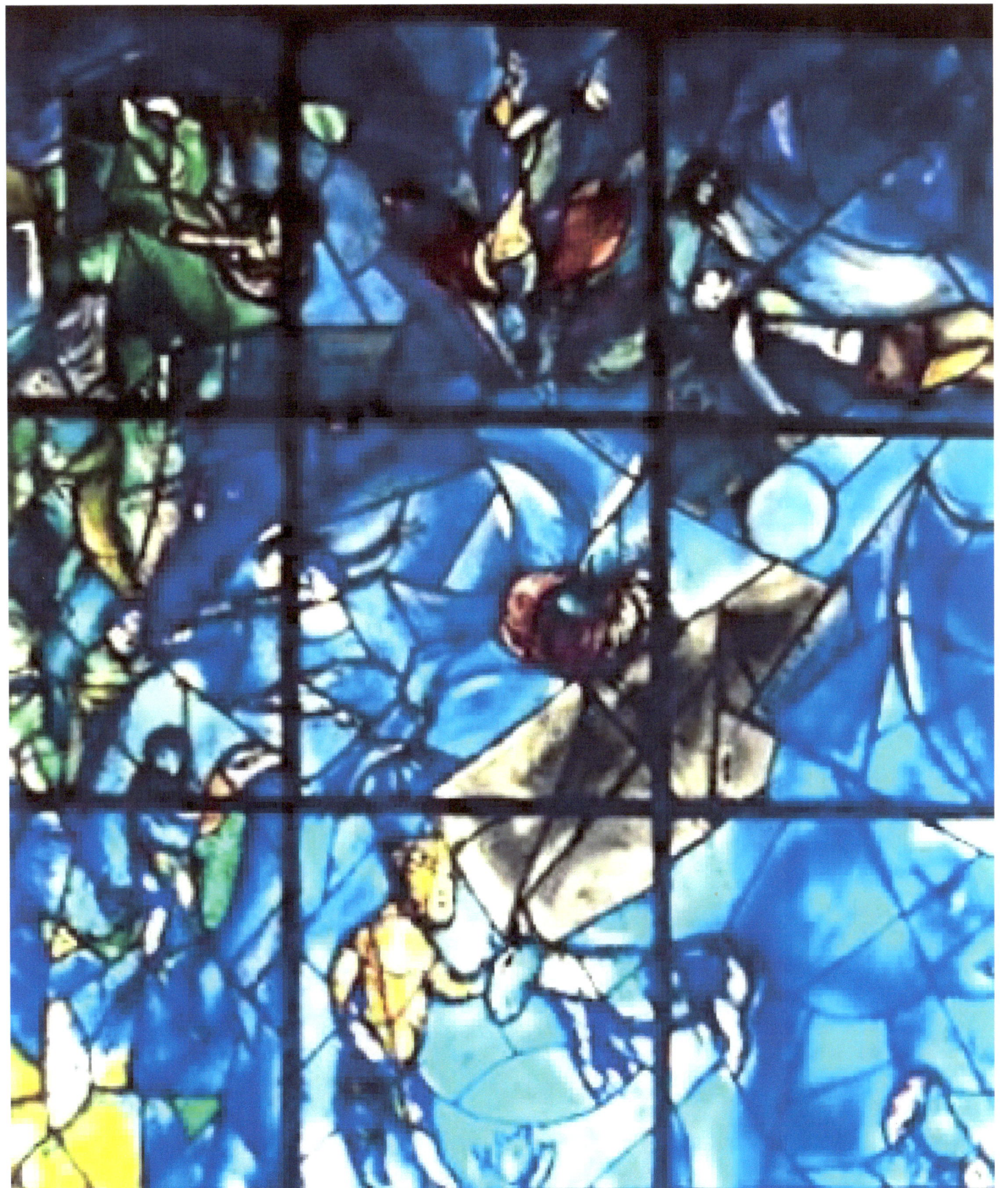
U.N. Frosted Glass Window Display

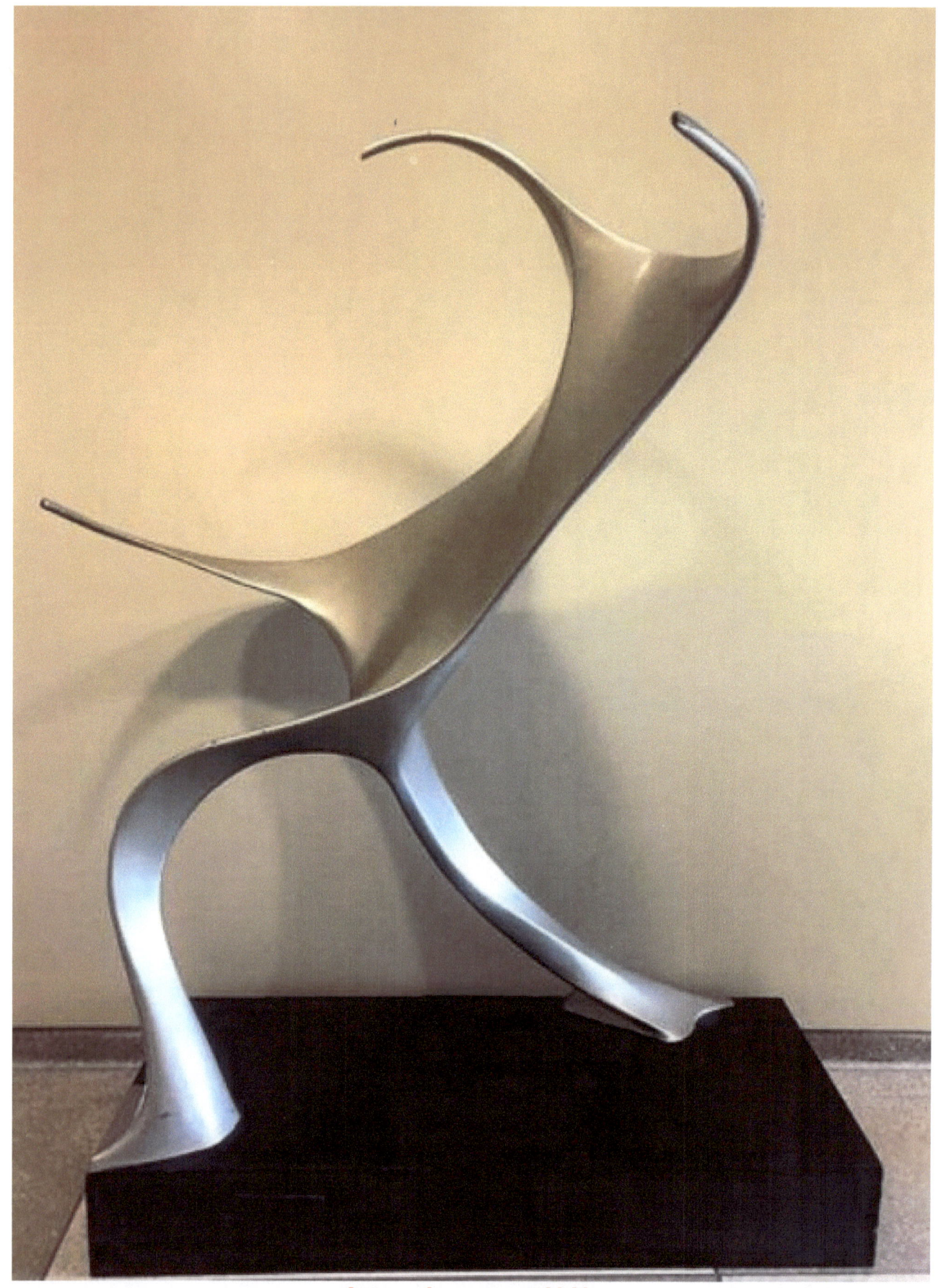

Artwork seen at U.N.